NATURAL VISIONS

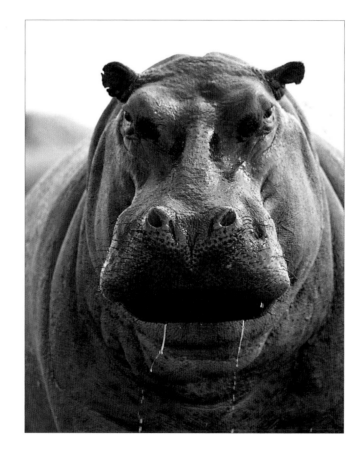

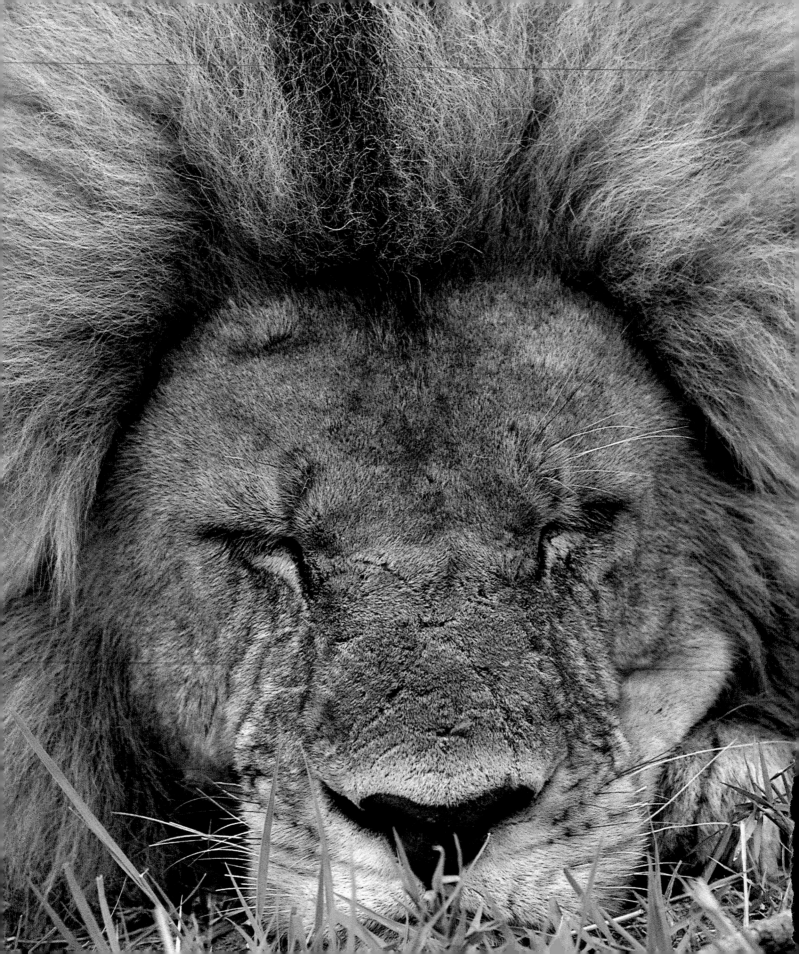

NATURAL VISIONS

Creative Tips for Wildlife Photography

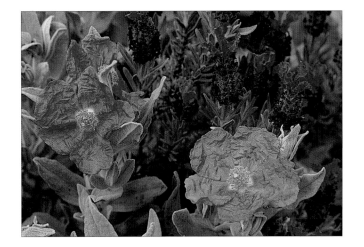

HEATHER ANGEL

COLLINS & BROWN

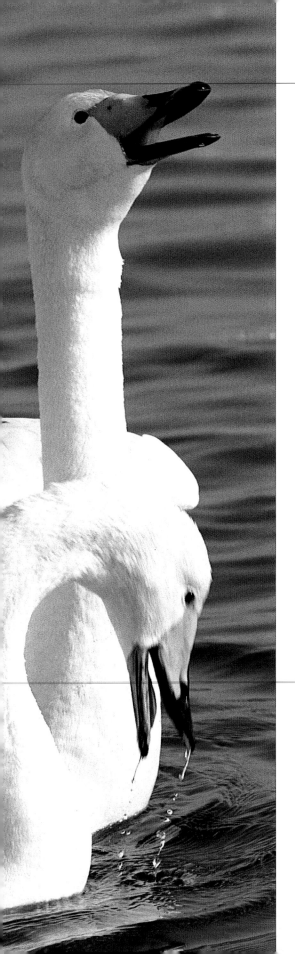

First published in Great Britain in 2000
by Collins & Brown Limited
London House
Great Eastern Wharf
Parkgate Road
London SW11 4NQ

1 3 5 7 9 8 6 4 2

British Library Cataloguing-in-Publication Data:
A catalogue record for this book is available from the British Library.

ISBN 1 85585 760 X (hardback)
ISBN 1 85585 788 X (paperback)

EDITORIAL DIRECTOR: Sarah Hoggett
DESIGNER: Claire Graham
EDITOR: Ian Kearey

Reproduction by Classic Scan Pte Ltd, Singapore
Printed and bound in Hong Kong China

Front cover: KING PENGUINS (*Aptenodytes patagonica*)
Back cover: LEOPARD (*Panthera pardus*)
Page 1: HIPPOPOTAMUS (*Hippopotamus amphibius*)
Page 2: SLEEPING LION (*Panthera leo*)
Page 3: GREY-LEAVED CISTUS (*Cistus albidus*) AND FRENCH LAVENDER (*Lavandula staechas*)
Page 4–5: WHOOPER SWANS (*Cygnus cygnus*)

CONTENTS

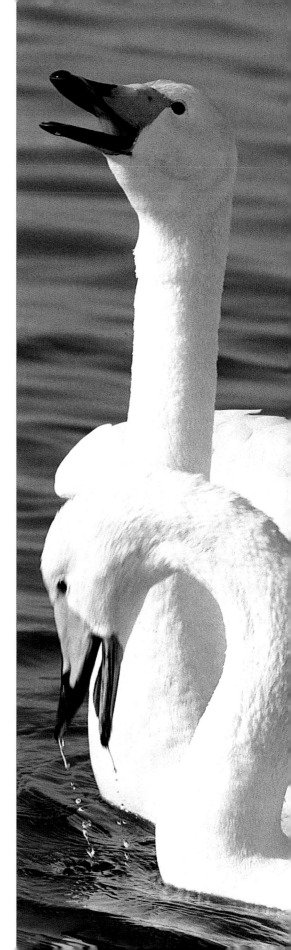

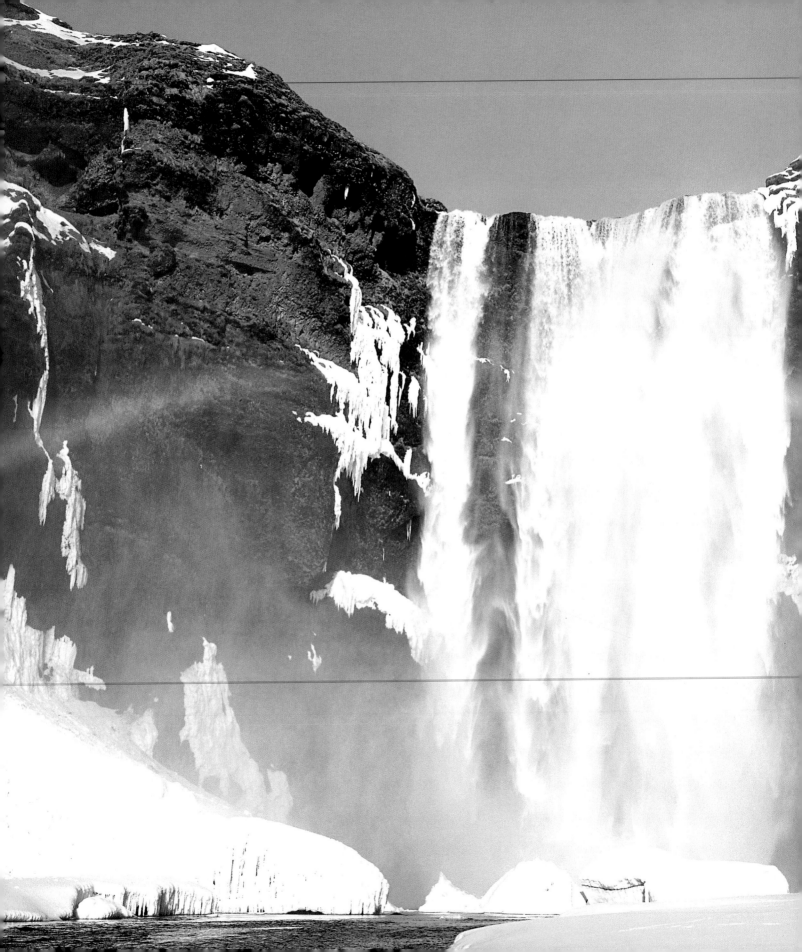

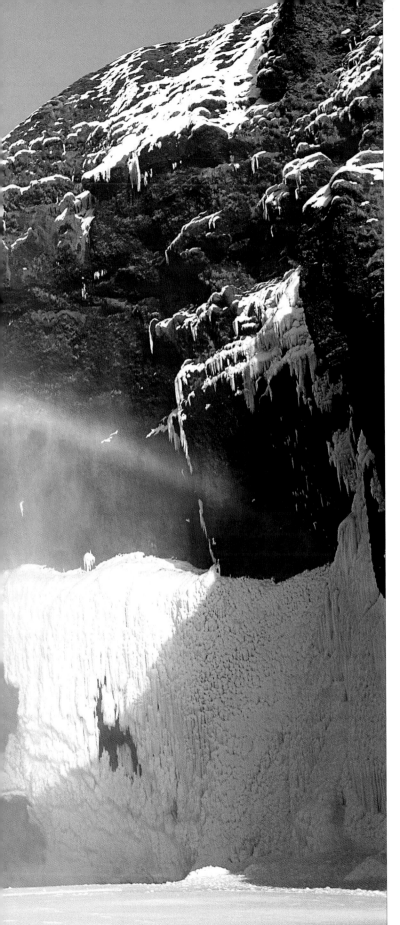

Introduction

THE DAWN OF A NEW millennium provides an appropriate time to reflect back and to look forward. On those occasions when the odds seem loaded against me, it is sobering to recall the difficulties wildlife photographers faced when working more than a century ago. For example, transporting cumbersome whole plate cameras into the field became a major expedition. The slow speed of the emulsion made static subjects virtually obligatory, and some nature photographers even resorted to posing stuffed animals out on location!

Today, lighter equipment and faster film stock no longer place limitations on where wildlife photographers can work, or what subjects they choose to photograph. Modern, sophisticated metering systems also make it relatively easy to get correctly exposed pictures. Memorable images, however, depend more on having fast hand-eye coordination to capture a fleeting moment, or the imaginative

WINTER RAINBOW

From a previous summer visit, I knew that if the sun was shining, a rainbow would be visible in front of the south-facing waterfall for much of the day. A polarizing filter helped enhance the saturation of the spectral colors.

Skogafoss with rainbow, Iceland, March

Camera: Hasselblad 501CM; Lens: 60mm
Film: Ektachrome 100S; Filter: Polarizing

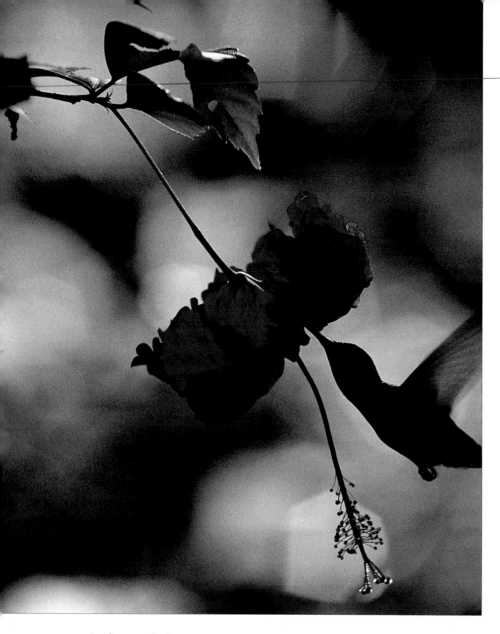

FLEETING VISIT

I framed this picture for the backlit flower with the diagonal line of the stem and the stigma. While I was focusing on the flower, a hummingbird appeared in the field of view long enough for me to take a single shot.

Hummingbird feeding on hibiscus flower, Monteverde, Costa Rica, April

Camera: Nikon F4
Lens: 105mm Micro-Nikkor
Film: Kodachrome 25

DIMINUTIVE FUCHSIAS

Although they lack petals, the tiny erect flowers produced by this native fuchsia from New Zealand are nonetheless quite exquisite. A side view and a shallow depth of field highlight the colorful stamens.

Fuchsia (*Fuchsia procumbens*), Royal Botanic Gardens, Kew, Surrey, England, June

Camera: Nikon F5
Lens: 105mm Micro-Nikkor
Film: Ektachrome 100S

mind needed to communicate artistic ideas within the camera (or on a computer at a later date), than on achieving an acceptable exposure.

The production of any photograph should be a fluid process as the eye initially perceives and the mind reacts to a scene or a subject. Just as the Internet can be surfed via different routes, so can a photograph be created as a result of different thought processes. The type and direction of light, the presence or absence of shadows, the tonal range, the degree of movement of the subject — not to mention the film stock and focal length of the lens — all affect the end result. With so many variable components, many decisions have to be spontaneous, yet any one can dramatically affect the way the image is conceived and executed.

Wildlife photography is inevitably something of a lottery, a blend of elation and frustration. Thorough research will, however, increase the chances of being in the right place at the right time. Even then, with two notoriously

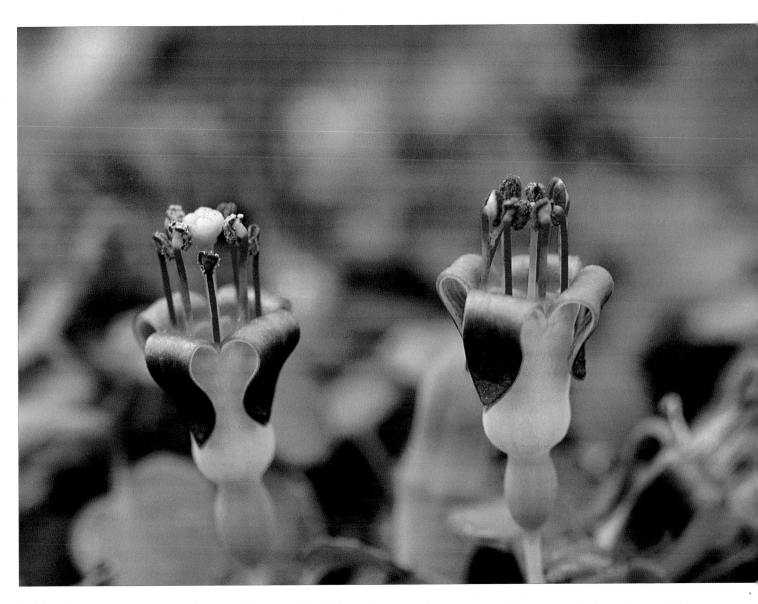

fickle elements — namely, weather and wild animals — time has to be invested in the field to ensure that the odds of interesting behavior coinciding with optimum lighting conditions are maximized.

The ways in which individual photographers see and select their images has always fascinated me. I consider myself fortunate indeed to set my own targets in a world that is my oyster. To anyone who naively assumes that it is less challenging to set your own parameters than work to a specific commission, I would argue that making your own investment up front ensures that both adrenaline and imagination must flow readily to gain marketable pictures. I appreciate only too well the need to change the pace by varying not only the focal length of lenses and camera angles, but also the shutter speed or depth of field that best suits the subject. If my primary goal fails, I can rapidly switch to something else without the shoot proving a disaster. Indeed, you will find several

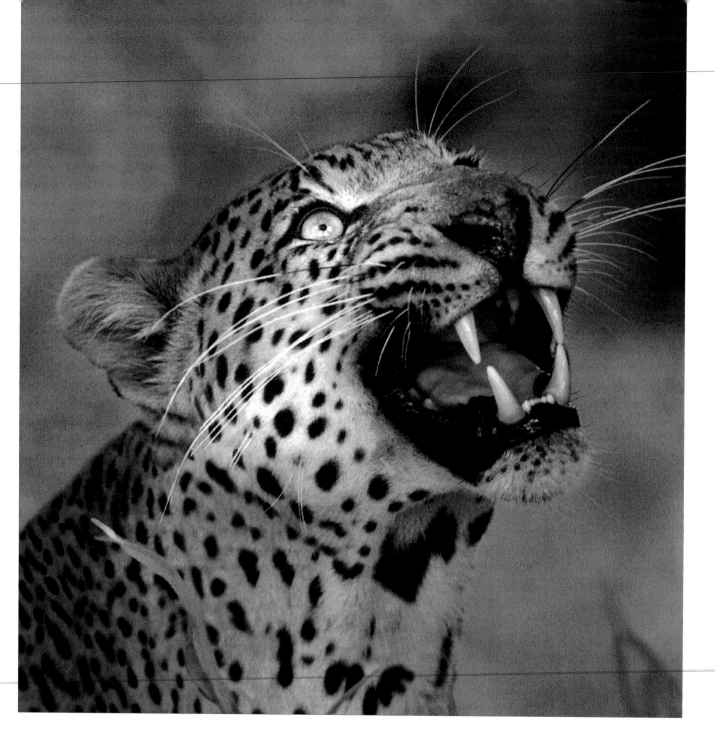

TERRITORIAL LEOPARD

Moments before I took this picture, I watched through the viewfinder in poor light as the leopard scent-marked a tree. As it looked up and snarled, I took a single frame of the dawn light bathing the side of the face.

Leopard (*Panthera pardus*), Moremi Game Reserve, Okavango Delta, Botswana, February

Camera: Nikon F5; Lens: 300mm; Film: Ektachrome 100S

references to just such a scenario within this book. Working to a specific brief may lead to a more limited approach and possibly missing a gem of a picture.

The subjective nature of a photograph makes it impossible to please everyone all the time. The images that stand the test of time, and which I remember most vividly, are invariably simple and uncluttered: I abhor confused backgrounds with conflicting colors that jar the eye. This does not mean, however, that memorable photographs have to follow a given formula: far from it, rules are made to be broken.

Essentially, I still strive to accept the challenge of composing the best picture possible with the camera. Nonetheless, as someone who is incapable of painting a picture, I relish the opportunity of working on a digital image after sundown or during non-photogenic weather. Now we have the tools to extend our vision beyond what we saw on location, to produce images that blur the boundaries between reality and art. Two examples of what I call my digitized art images are published here for the first time.

On the other hand, when digital enhancement is used to increase the density of sparsely distributed game animals by cloning individuals so that they cover every blade of grass, or to depict behavior that did not exist in reality, and is not declared as such, it is quite simply portraying an untruth. A retrogressive aspect of digital imaging is that some photographers now adopt a more casual attitude to the way they compose their pictures. For my money,

shooting like crazy and digitizing out all the distracting elements at a later date can never be an inspired way to create pictures.

The selection of images for this volume inevitably reflects my personal passions, which inspire me to continue my quest to portray the rich tapestry of life on our biodiverse planet.

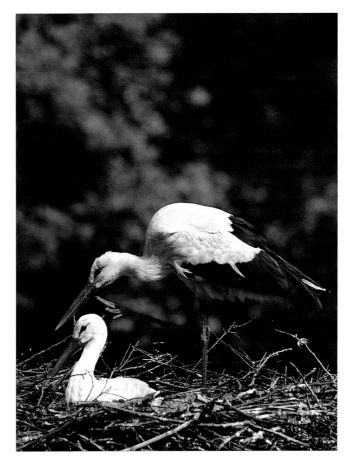

STORK COUPLE

By climbing onto a roof, I could work at eye level with the storks' nest. The juxtaposition of the two birds resulted in a picture in which a foot used by one to scratch itself appears as if it is about to pat its mate on the head.

White storks (*Ciconia ciconia*) on nest, Poland, May

Camera: Nikon F4; Lens 500mm; Film: Ektachrome 100S

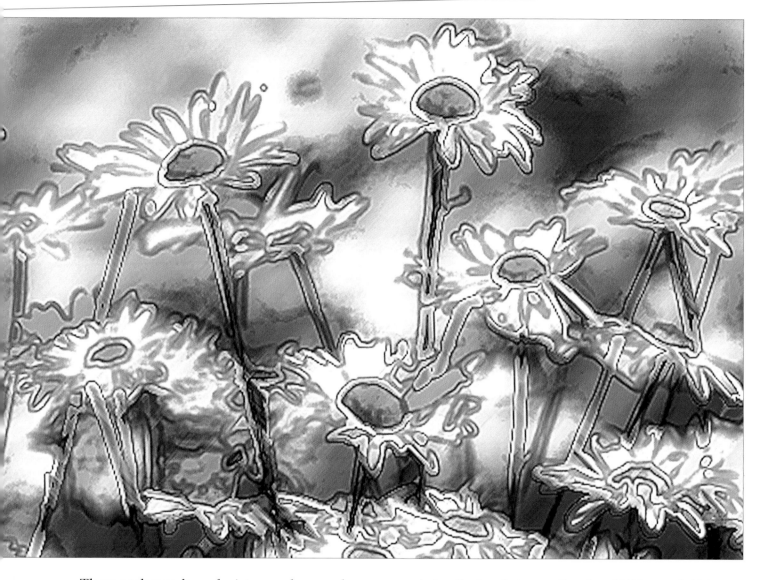

They embrace broad vistas, ephemeral cameos as well as intimate microcosms, and also reflect changing trends in wildlife photography, as the demand for pin-sharp portraits has swung toward the portrayal of animals in their habitats, and to the depiction of animal behavior and movement.

As the sheer volume of excellent portraits spirals ever upward, wildlife photographers have had to extend their vision to fire new life into their pictures. In the 1970s and '80s we strove to produce pin-sharp portraits in fading light, using medium-speed films with obvious grain. How ironic it is that, now that such films are available with greatly enhanced definition, the current vogue is for motion blur! Certainly my own work has gradually evolved to convey a more visual approach.

In this book I reveal what attracted me to the image in the first place, and how I chose to

DAISY OUTLINES

Using a transparency of ox-eye daisies that lacked luster, I produced a digitized art image using Adobe Photoshop.

Ox-eye daisies (*Leucanthemum vulgare*), Sussex, England, June

Camera: Nikon F5
Lens: 105mm Micro-Nikkor
Film: Ektachrome 100S

SWINGING APE

Obliquely lit from behind, a young orangutan emerges from the tropical forest, deftly swinging from branch to branch using all four digits.

Orangutan (*Pongo pygmaeus*), Tanjung Puting, Kalimantan, Indonesia, July

Camera: Nikon F4
Lens: 300mm
Film: Kodachrome 200

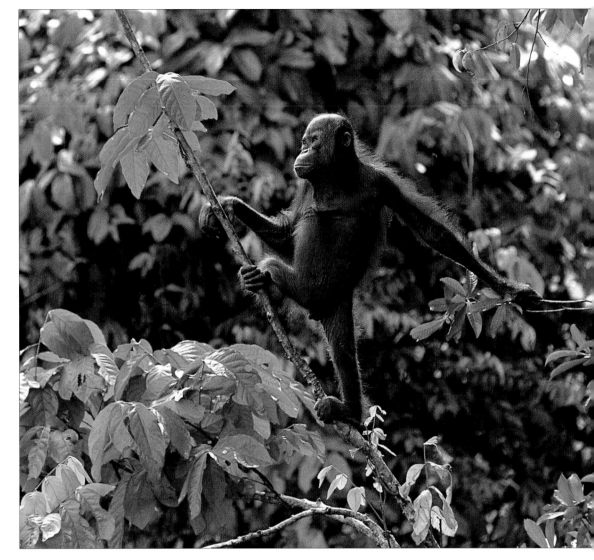

frame it, or select a particular film or shutter speed. By placing the text on the same spread as the image, I hope to encourage you, the reader, to look repeatedly back and forth between the two, thereby gaining better insight into not only my own vision of the natural world, but maybe your own as well.

When I began to use a camera as a tool to document the specimens I collected as a marine biologist, I had no desire to become a photographer. Without any formal training, fascination soon became an obsession, which led to a lifelong voyage of discovery. I shall forever be grateful that for more than a quarter of a century my photographic quests have lured me to countless remote locations, where I have been privileged to experience a phenomenal variety of wildlife that shares our world. Would I repeat those years? You bet I would.

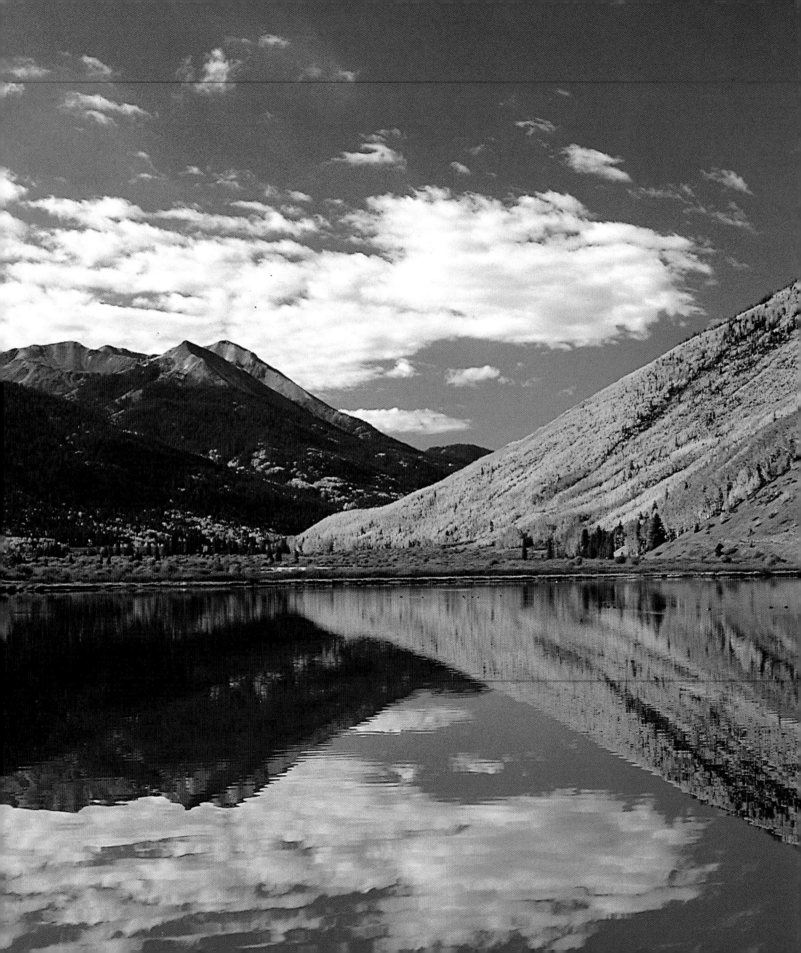

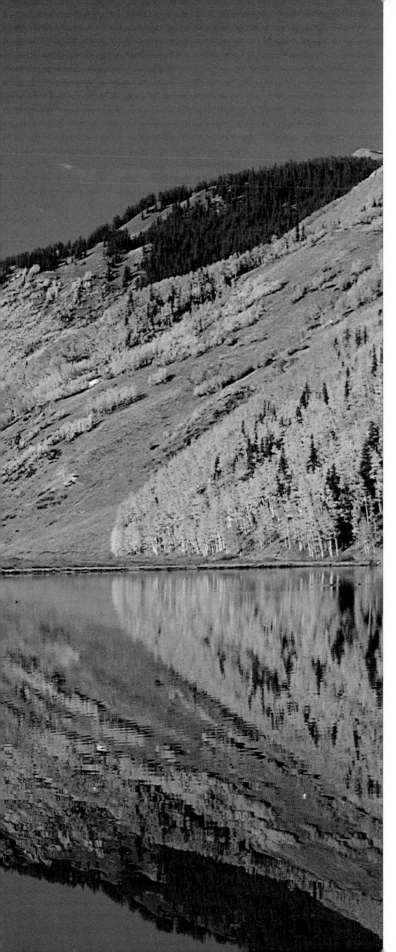

The Natural Environment

PORTRAYING ANY NATURAL environment in the best possible way is always a challenge, but considerably more time can be invested waiting for the optimum light of a natural habitat than when photographing an active animal. My philosophy is that the picture should convey a sense of being there. Certain scene-setting elements — such as desert sand or polar ice — can instantly convey the habitat. Similarly, colors can convey the season: the fresh greens of spring, the brightly colored flowers of summer, the flaming foliage of fall, and the white snow of winter. Using a wide-angle lens may be an effective technique, but it is by no means obligatory for showing the environment; in fact, a vast expanse of sky is warranted only if it adds color or has dramatic clouds.

GOLDEN MANTLE

Vibrant, yellow aspen foliage takes on a luminous quality against a clear blue sky. On my first morning, a persistent breeze killed any hint of a reflection in the lake, but the next day was a different story. As the sun rose to the left, I used a polarizing filter to enrich the sky and foliage colors.

Autumn scene reflected in Crystal Lake, San Juan Mountains, Colorado, USA, September

Camera: Nikon F4S; Lens: 35–70mm
Film: Ektachrome 100S; Filter: Polarizing

SCULPTED ICEBERGS

Calved from the snout of Iceland's largest glacier, icebergs float out into a glacial lagoon. Sun, wind, and varying water levels in this tidal lake constantly erode and sculpt the bergs. The black lines in the ice arise when volcanic debris showers down onto the glacier. Freshly exposed ice tends to be blue, and gradually turns white as internal water is replaced by air. Overcast weather without strong shadows and calm water provided ideal conditions for portraying the colors of the bergs, together with their reflections in the lake.

Icebergs in Jökulsárlón,
Iceland, July

Camera: Nikon F4; Lens: 300mm
Film: Ektachrome 100S

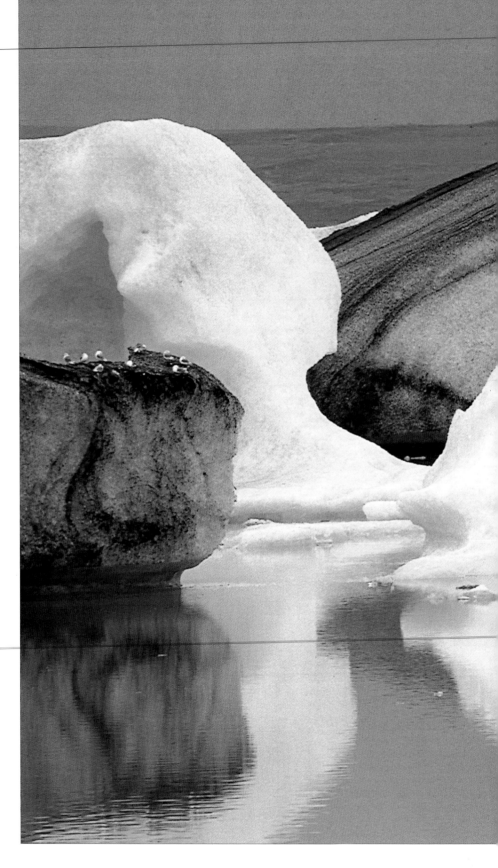

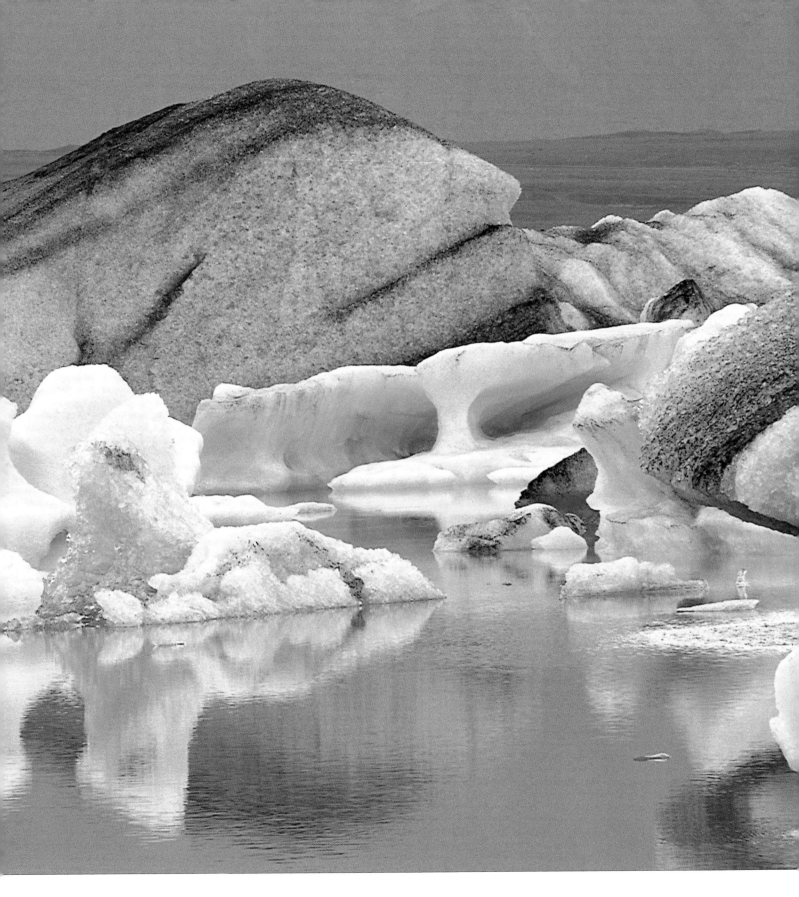

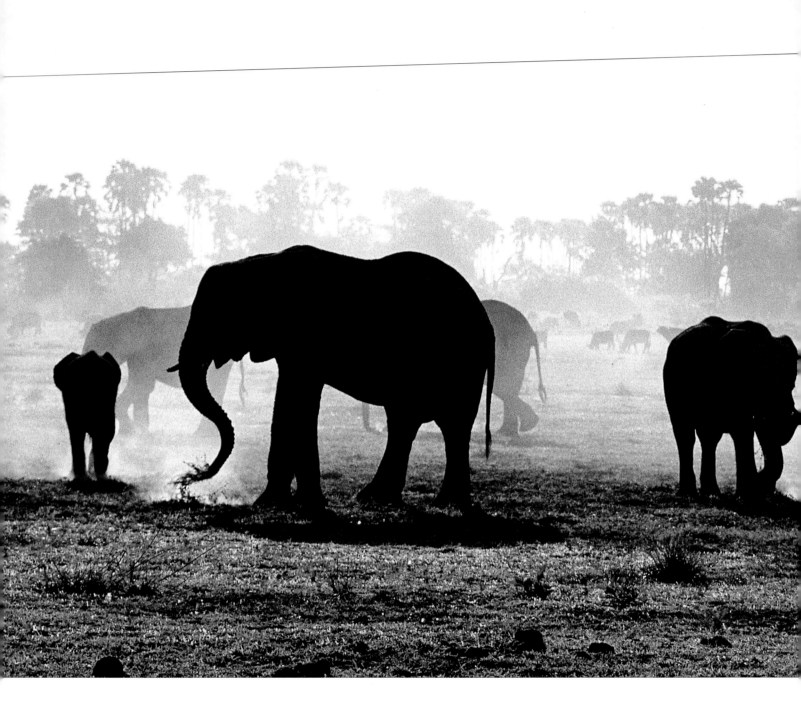

SHAPELY SILHOUETTES

Many a game drive in Africa becomes a voyage of discovery, as happened when I decided to abort a quest for cats and follow a large elephant herd that interrupted the path of my jeep. After half an hour the gentle giants halted in an area recently exposed by receding floodwater, where they kicked up trailing stems of aquatic plants before plucking them from the ground with their trunks. The dust helped to accentuate the strong silhouettes.

African elephants (*Loxodonta africana*) feeding, Moremi Game Reserve, Okavango Delta, Botswana, November

Camera: Nikon F4; Lens: 300mm; Film: Ektachrome 100S

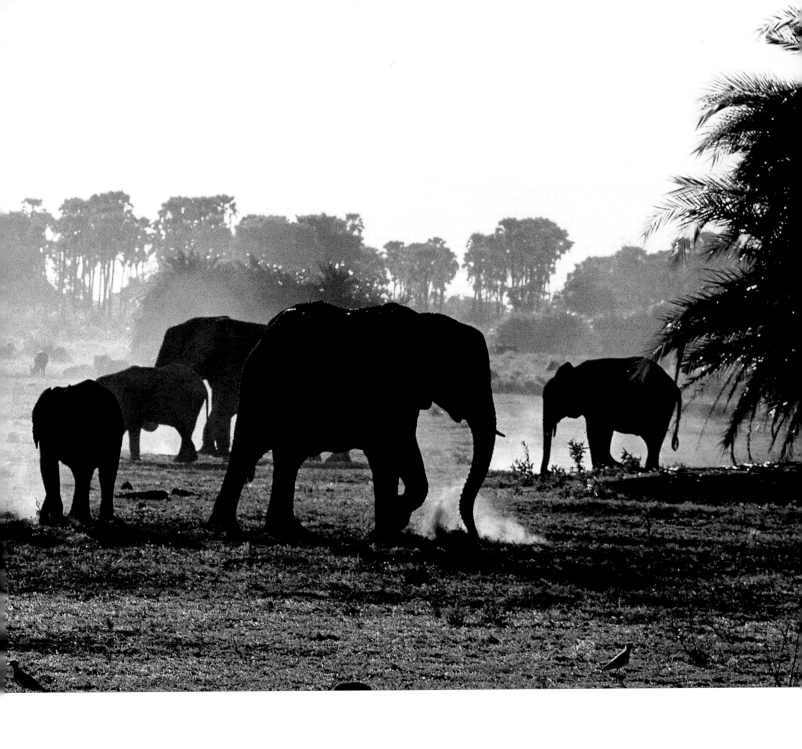

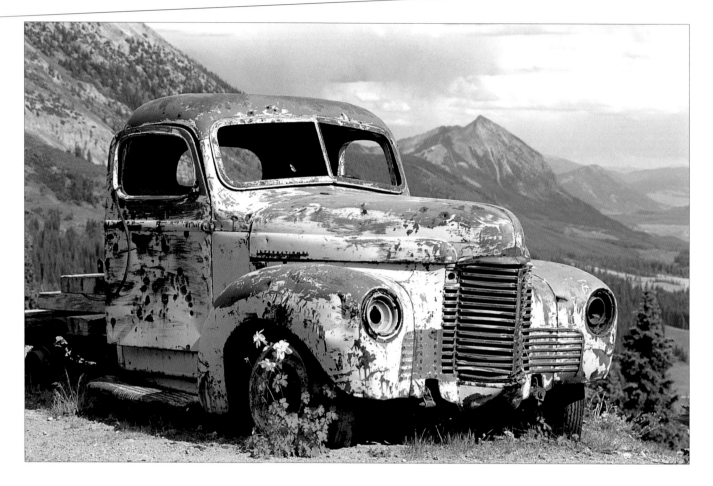

CARCASS

A vehicle abandoned 10,000 feet (3,048 meters) up a mountain road was a conspicuous blot in an otherwise pristine landscape. When I walked around the truck I found the Colorado columbine flowers — perfectly framed by the wheel arch — helping to soften the rusty hulk. An oblique camera angle ensured that some distant peaks appeared in the frame. Within a few years, this unwelcome eyesore would become softened by more wild plants.

Abandoned vehicle with Colorado columbine (*Aquilegia caerulea*), near Crested Butte, Colorado, USA, July

Camera: Nikon F4; Lens: 80–200mm
Film: Ektachrome 100S

BURNISHED BEECHES

Once the peak fall colors develop in deciduous forests, a narrow time slot remains for photography before a flurry of falling leaves reveals stark, skeletal trunks. Here, the trees grow within a hollow and are well protected from wind. Soft light, without a breath of wind, provided perfect conditions for using a long exposure to photograph the gold and bronze foliage inside this ancient Chilterns beech wood.

Beech trees (*Fagus sylvatica*) in Burnham Beeches, Buckinghamshire, England, May

Camera: Nikon F4; Lens: 80–200mm
Film: Ektachrome 100S

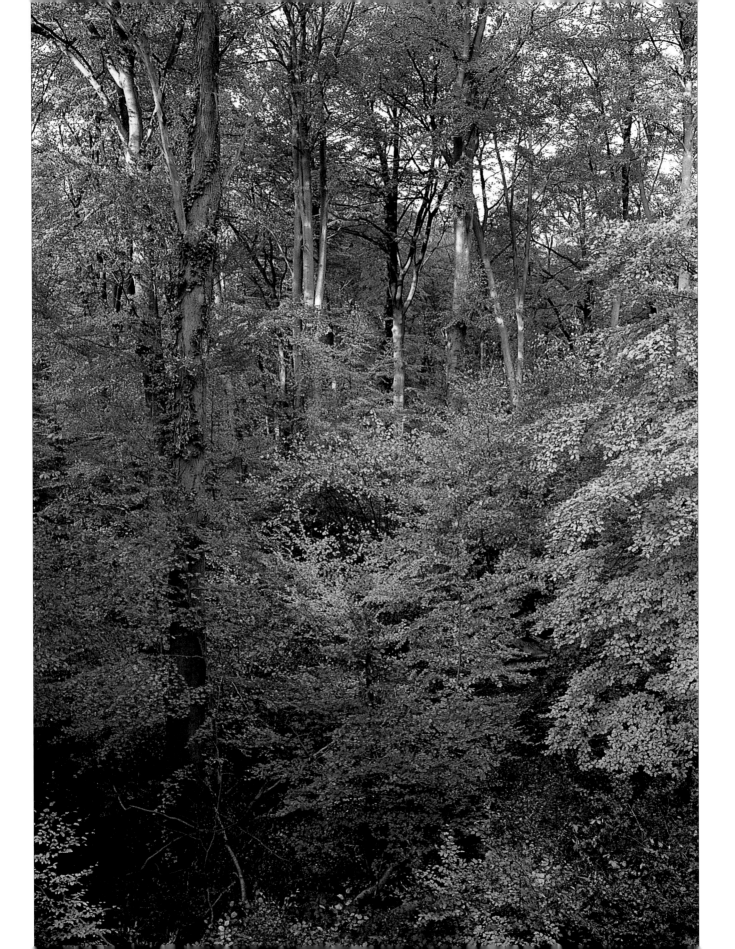

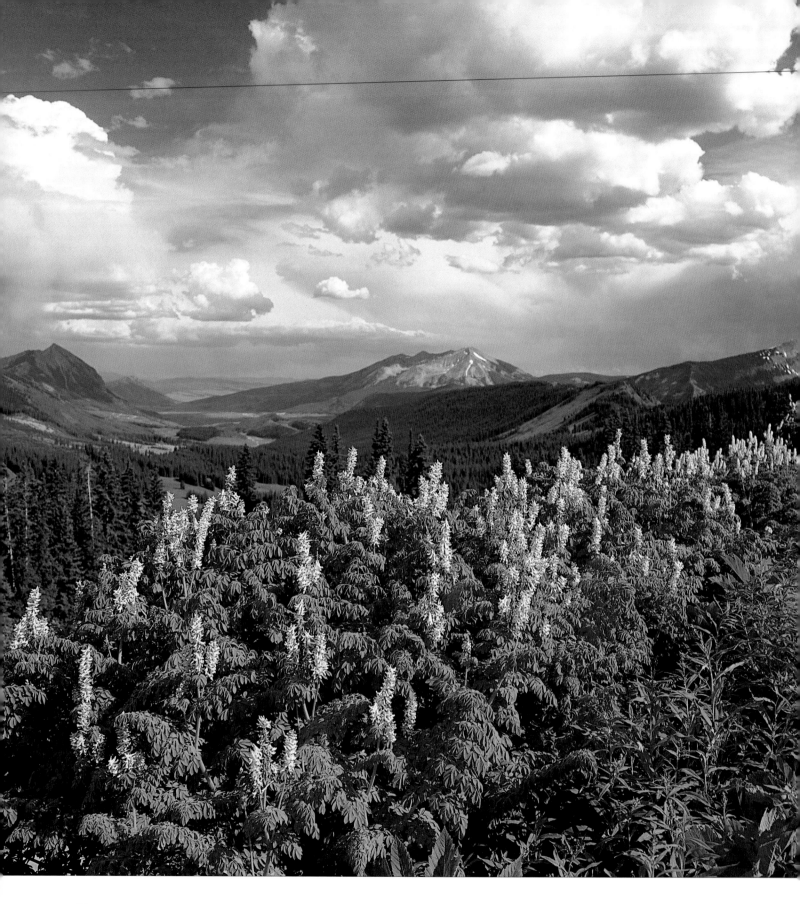

FLORAL STAND

It is rare to drive up a mountain road and find a perfect summer scene within a few paces of the vehicle. The individual flowers are unspectacular, but together they make an impressive foreground stand to the mountainscape as they reach for the sky. The distant, fluffy, white clouds not only echo the flowers but also balance the dominant stand by providing the three-part landscape with a substantial distant element. Without the clouds, the composition would have been bottom-heavy.

Case's fitweed (*Corydalis caseana*),
near Crested Butte, Colorado, USA, July

Camera: Hasselblad 501CM; Lens: 60mm
Film: Ektachrome 100

GREEN RIBBON

Exposed limestone beds sculpted by the action of rain and frost develop enlarged fissures in which plants can thrive. On reaching the surface, however, the plants become pruned by wind as well as browsing sheep and rabbits. To ensure even lighting on both the green plants and gray rocks, I rose early to use soft, indirect light without contrast. Even so, I searched for two hours before the curved diagonal line, which runs through the frame from bottom left to top right, caught my eye.

Hart's-tongue ferns (*Phyllitis scolopendrium*) in limestone pavement, Malham, Yorkshire, England, May

Camera: Nikon F4; Lens: 35–70mm
Film: Ektachrome 100S

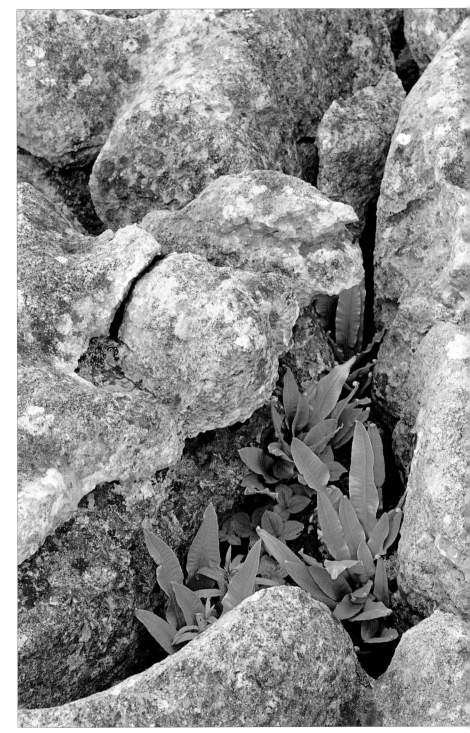

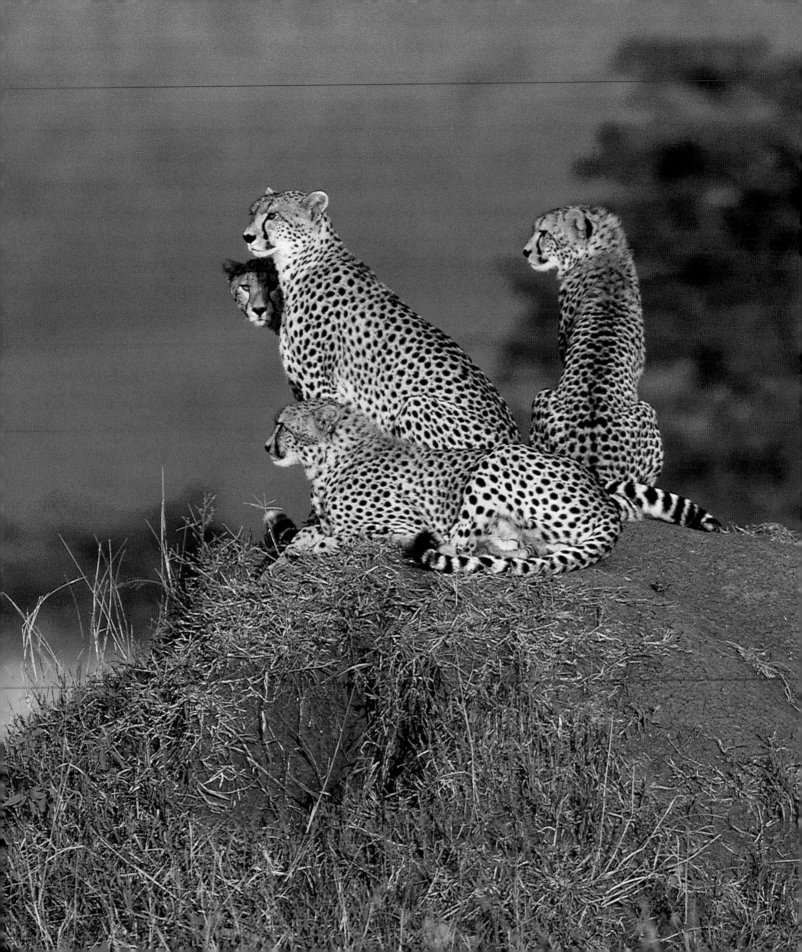

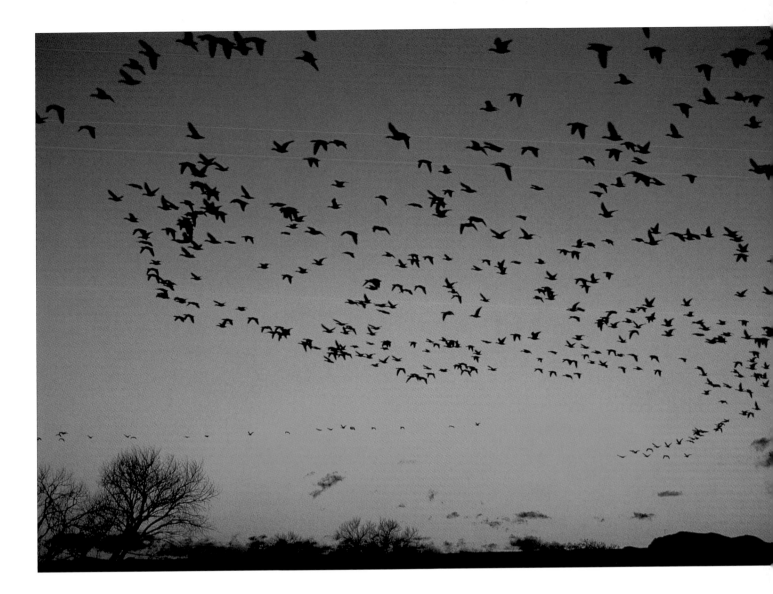

VANTAGE POINT

In flat, savannah grasslands, cheetahs regularly use old termite mounds at dawn and dusk as elevated lookouts to locate their prey. The single cub peering directly at the camera, while its mother and siblings remain focused on game moving out of shot to the left, makes this study of a cat family bathed in a rich, golden, dusk light. I exposed just this single frame before the cub averted its gaze.

Cheetah (*Acinonyx jubatus*) family on a termite mound, Masai Mara National Reserve, Kenya, August

Camera: Nikon F4; Lens: 300mm
Film: Ektachrome 100 Lumière

DUSK LIFT-OFF

Twice a day — at dawn and dusk — overwintering wild-fowl migrate to and from their feeding grounds. They tend to be more concentrated at dusk, as shown here. I checked out the flight path of the first return wave so that I could judge the best camera position, selecting a wide-angle lens in readiness for the swirling, silhouetted lines. As the light deteriorated, I decided to push an ISO 200 film one stop.

Snow geese (*Anser caerulescens*) at dusk, Bosque del Apache National Wildlife Refuge, New Mexico, USA, December

Camera: Nikon F4; Lens: 20mm
Film: Ektachrome 200 rated at ISO 400

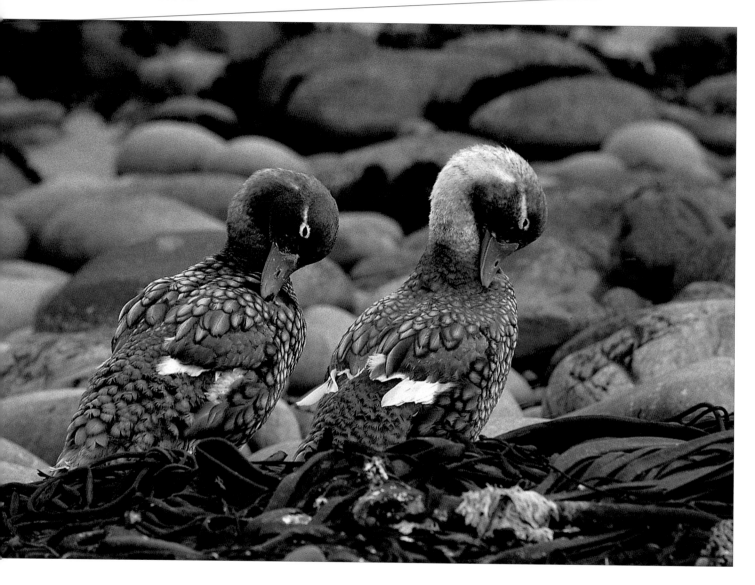

SYNCHRONOUS PREENING

When I spotted a gaggle of flightless steamer ducks swimming in a bay, I crouched inside
tussock grass until they came ashore. Approaching cautiously, I framed a pair preening
in unison, showing the seaweed strandline with the boulder beach behind. The ducks
reminded me of synchronized swimmers, who move as one. With an overcast sky, the
light was poor, but a medium-speed film allowed a fast shutter speed to ensure that
the birds were not spoiled with unintentional blur.

Flightless steamer ducks (*Tachyeres brachypterus*) preening,
Sea Lion Island, Falkland Islands, November

Camera: Nikon F4; Lens: 300mm; Film: Kodachrome 200

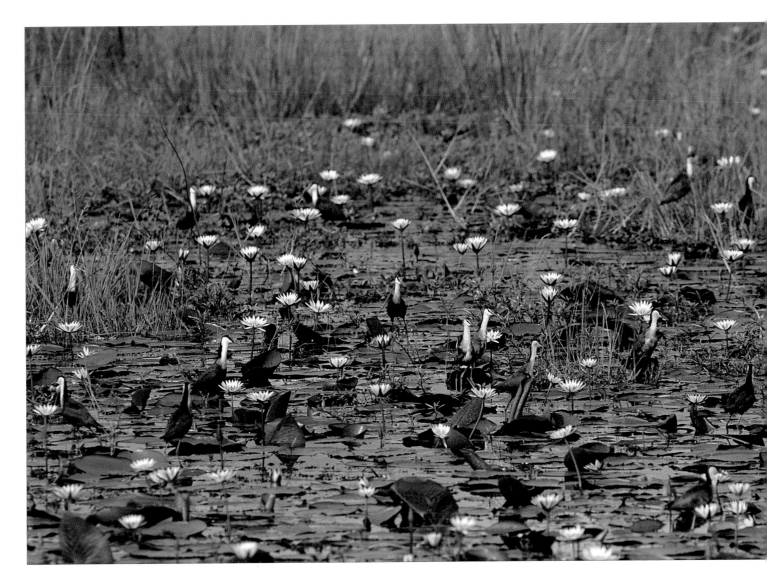

MASTERS OF DISGUISE

A long, fast lens is invaluable for separating a mammal or bird from a defocused background. I was therefore intrigued to discover from an elevated knoll how superbly these jacanas were camouflaged amongst indigenous water lilies. Here, the rufous bodies mimic the undersides of lily pads uplifted by wind, the white necks the pallid, open blooms, and the blue frontal shields the breaking buds. For the record, there are fifteen birds in this frame.

African jacanas (*Actiphilornis africana*) amongst water lilies (*Nymphaea nouchali* var. *caerulea*), Moremi Game Reserve, Okavango Delta, Botswana, February

Camera: Nikon F5; Lens: 500mm
Film: Ektachrome 100S

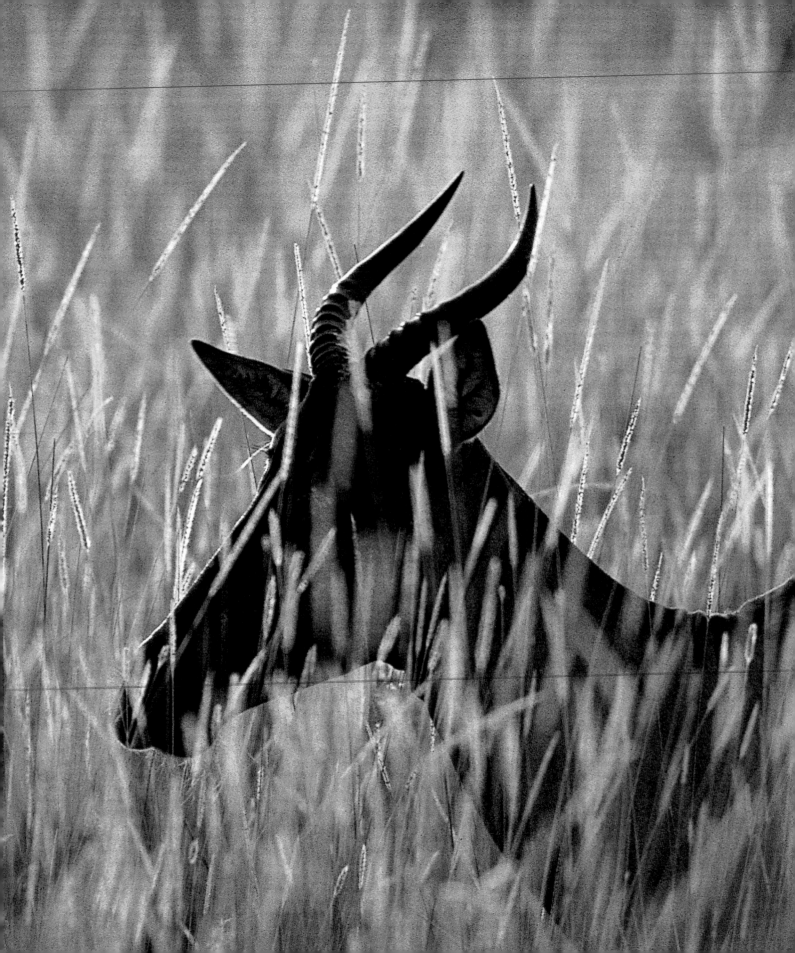

Using the Light

NOTHING IN THE natural world is predictable, least of all lighting, yet the direction and quality of light is everything: it can make or mar an image. Grasping dramatic transient light never fails to be a thrilling experience, whereas wasting hours for abysmal light to improve is so frustrating. Nonetheless, if you want to achieve a memorable picture, it is worth waiting to capture the optimum lighting. For example, strong sidelighting will cast shadows that can play a powerful element within a composition. Depending on the physical nature of the subject, backlighting, on the other hand, may create a visible glow, a rimlit halo, or a solid silhouette. The soft, shadowless lighting produced by a light cloud cover is perfect for pastel-tone flowers.

RIMLIT PORTRAIT

During the wet season in Africa, game viewing is more difficult as grasses grow apace, but at first and last light, flowering grass heads take on a beauty of their own. Here, partially hiding a rimlit tsessebe, these flowering rat's-tail grasses perfectly encapsulate the time and place.

Tsessebe (*Damaliscus lunatus*) amongst rat's-tail grasses at dusk, Moremi Game Reserve, Okavango Delta, Botswana, February

Camera: Nikon F5; Lens: 500mm
Film: Ektachrome 100S

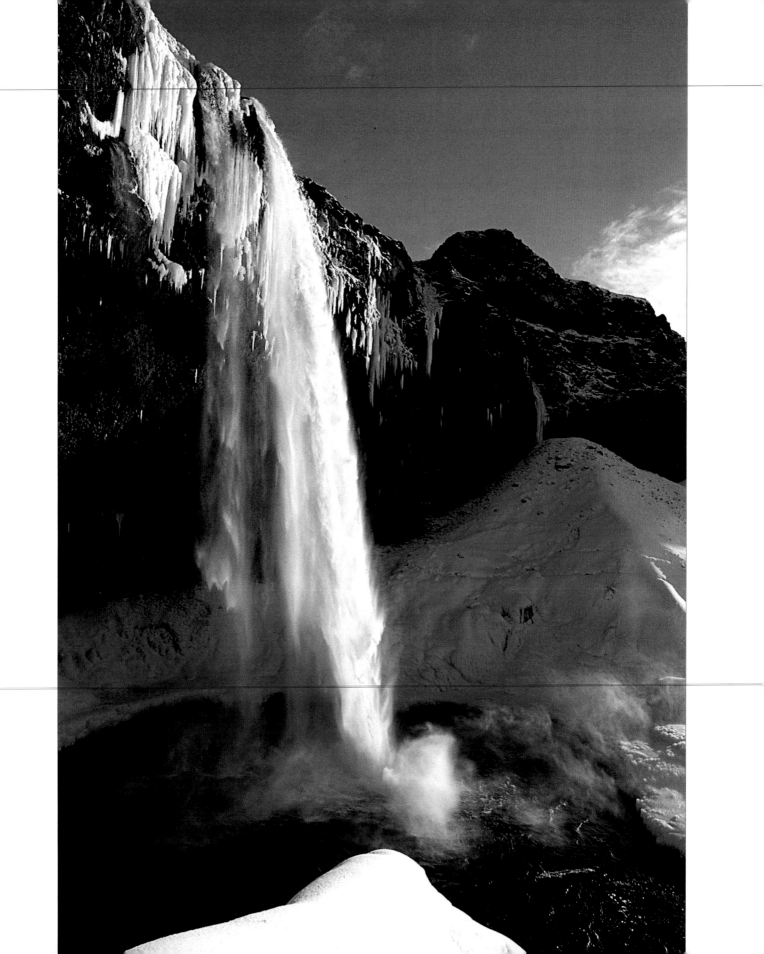

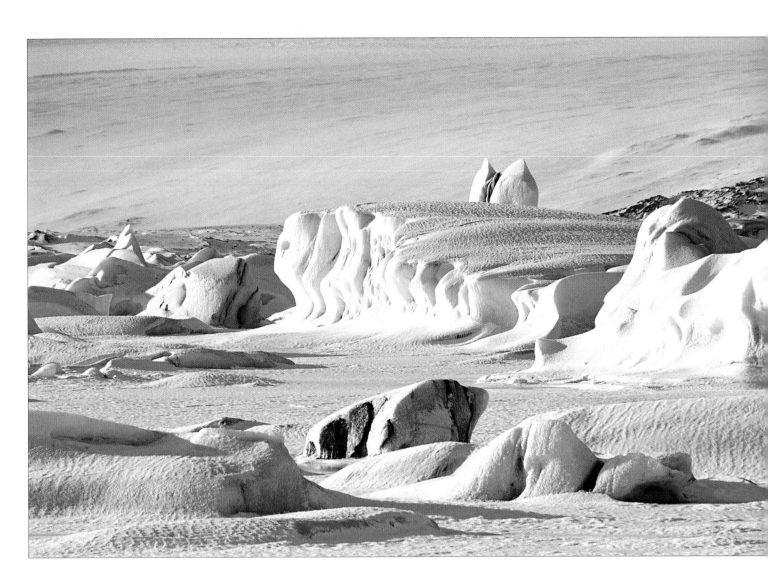

WINTER WATERFALL

I waited four hours for the sun to move around a rock,
to fire life into the spray from the curtain hitting the
plunge pool. It is no accident that the ice-encrusted,
triangular knoll lines up with the base of the fall, and
they both contrast with the dark pool and vertical rock
face. A polarizing filter darkened the blue sky.

Framed by icicles, Seljalandsfoss cascades into an
unfrozen plunge pool, Iceland, March

Camera: Nikon F5; Lens: 20–35mm
Film: Ektachrome 100S; Filter: Polarizing

FROZEN LAKE

Icy roads with snow blowing across them meant that it
took far longer than I had expected to reach a glacial lake
I knew from summer visits. I arrived just half an hour
before the sun disappeared behind a hill, but the shadows
cast by the long-angled, winter light perfectly modeled the
snow-dusted bergs locked in the frozen lake.

Icebergs in Jökulsárlón, Iceland, March

Camera: Nikon F5; Lens: 300mm
Film: Ektachrome 100S

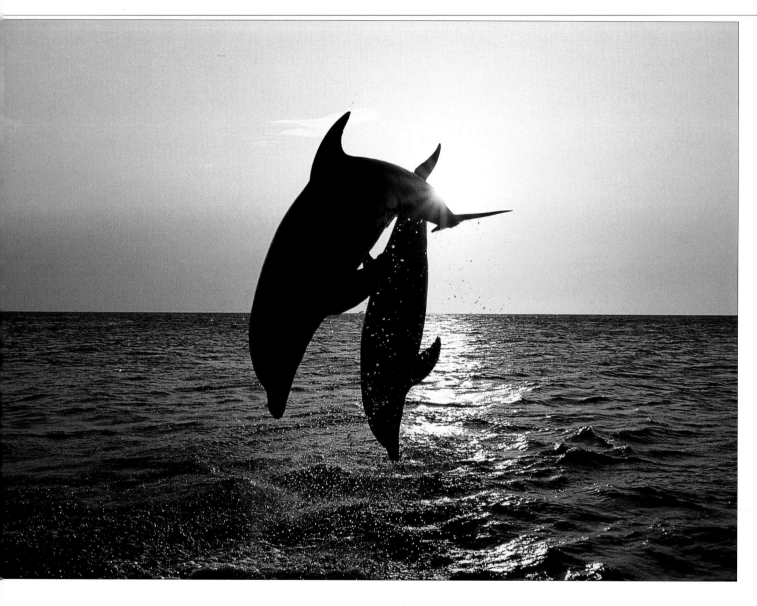

DOLPHIN SILHOUETTES

Working from a boat at sea, I was not sure where the dolphins would leap in relation to the setting sun. I played it safe by manually prefocusing a wide-angle lens, which allowed me plenty of space around the dolphins. I also chose to hand-hold the camera so that I could rapidly fine-tune the composition. To expose for the silhouettes, I manually metered off the sky, and gained a natural sun starburst as a bonus.

Bottle-nosed dolphins (*Tursiops truncatus*) leaping from sea at sunset, Roatán, Honduras, May

Camera: Nikon F4; Lens: 20–35mm; Film: Ektachrome 100 Plus

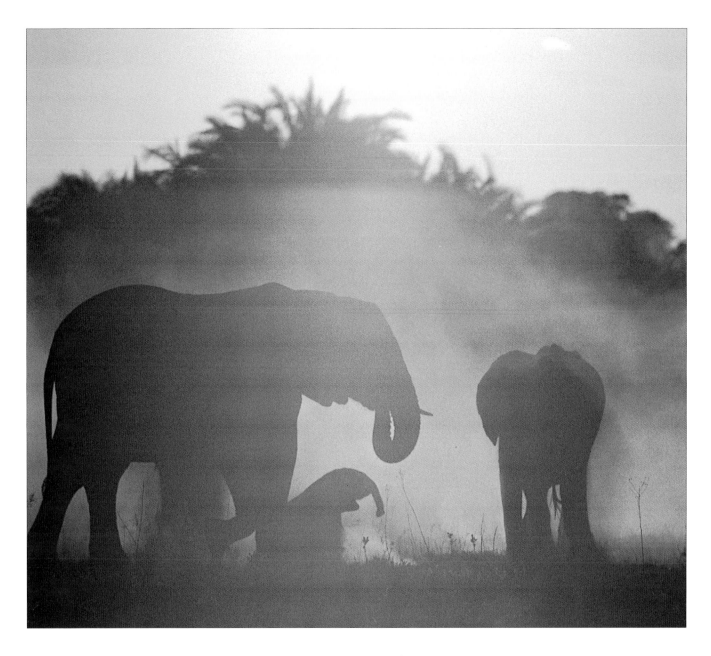

FORAGING AT DUSK

The fluid nature of any mobile herd makes it difficult to capture simple silhouettes — when bodies overlap, they create curious anatomical misfits that appear to have odd numbers of legs. This is why it is vital to constantly appraise the scene with the naked eye. As the sun sank toward the horizon, I was rewarded by ghostly silhouettes of elephants, looming from a fiery aura of dust to reveal a tiny baby.

African elephants *(Loxodonta africana)* feeding at dusk,
Moremi Game Reserve, Okavango Delta, Botswana, November

Camera: Nikon F4; Lens: 500mm; Film: Ektachrome 100S

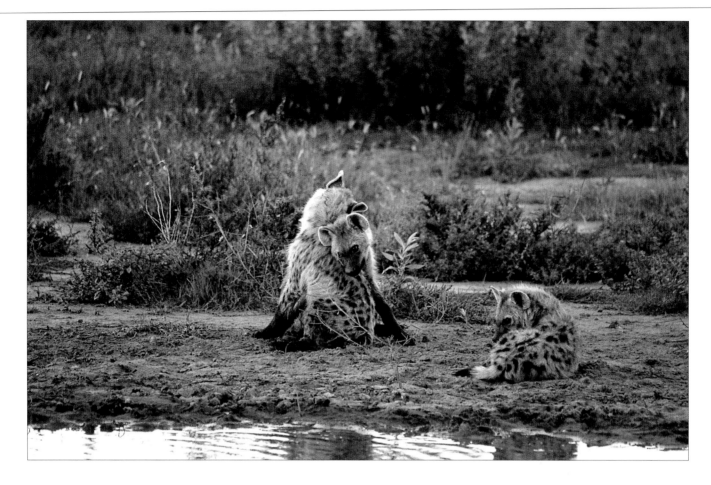

PAINTING WITH LIGHT

The light was fading fast when I spotted sibling hyenas playing beside a pond at dusk. The only way I could grab a few frames of a red shaft beaming through the clouds onto the playful pair was to push a film already loaded in the camera. This was a case when it was prudent to lose a few frames of palm trees (which were rated at ISO 100) by uprating the film to ISO 200, thereby gaining a faster shutter speed to freeze the mobile hyenas.

Young spotted hyenas (*Crocuta crocuta*) playing at dusk, Moremi Game Reserve, Okavango Delta, Botswana, February

Camera: Nikon F5; Lens: 500mm
Film: Ektachrome 100S rated at ISO 200

MOONLIGHTING

One evening, after snow geese had flown into their roosting sites, the sun disappeared and the sky turned pink. Other photographers departed as the temperature plummeted, but I lingered to watch the rosy sky turn dark blue as a full moon rose, spotlighting a gaggle of geese. Knowing I had only minutes before the moon would rise too high to gain a meaningful composition, I pushed 200-speed film to ISO 400 to gain an extra stop.

Snow geese (*Anser caerulescens*) spotlit by full moon, Bosque del Apache National Wildlife Refuge, New Mexico, USA, December

Camera: Nikon F4S; Lens: 300mm
Film: Ektachrome 200 rated at ISO 400

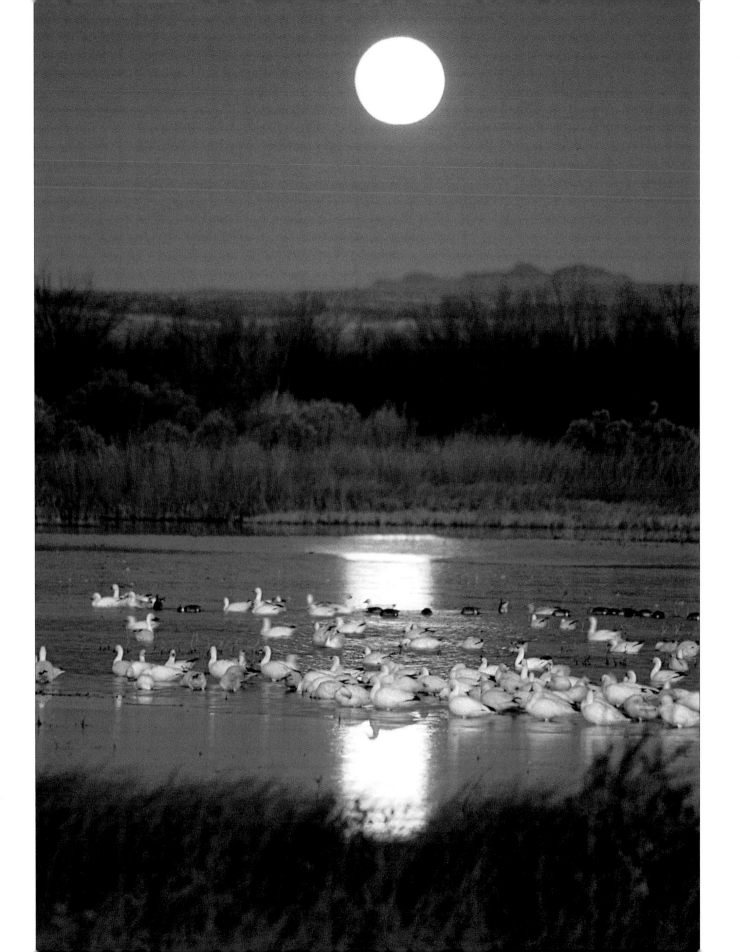

SILHOUETTED PALMS

African sunrises and sunsets may be brief, but they can be spectacular. At these times of day, when the sky is clear, I search out good viewpoints to depict individual game animals or trees as simple silhouettes.

Fan palms (*Hyphaene petersiana*) at sunrise,
Moremi Game Reserve, Okavango Delta, Botswana,
February

Camera: Nikon F5; Lens: 300mm
Film: Ektachrome 100S

LEAF MOSAIC

The arrangement of leaves on a twig, characteristic for each kind of tree, forms a distinct pattern, or leaf mosaic. I decided that the best way to compare the profiles of feathery leaves — both intact and eaten — on a Flamboyant tree was to silhouette them against the sky using a long lens.

Leaf mosaic of Flamboyant tree (*Delonix regia*),
Bogor Botanical Gardens, Java, Indonesia, July

Camera: Nikon F4; Lens: 300mm
Film: Ektachrome 100 Plus

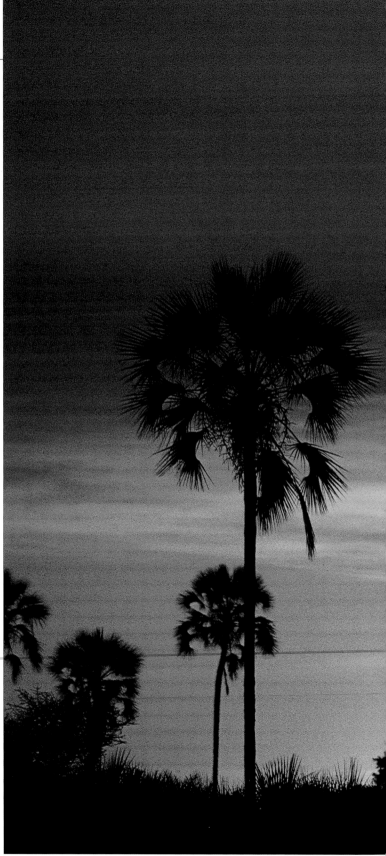

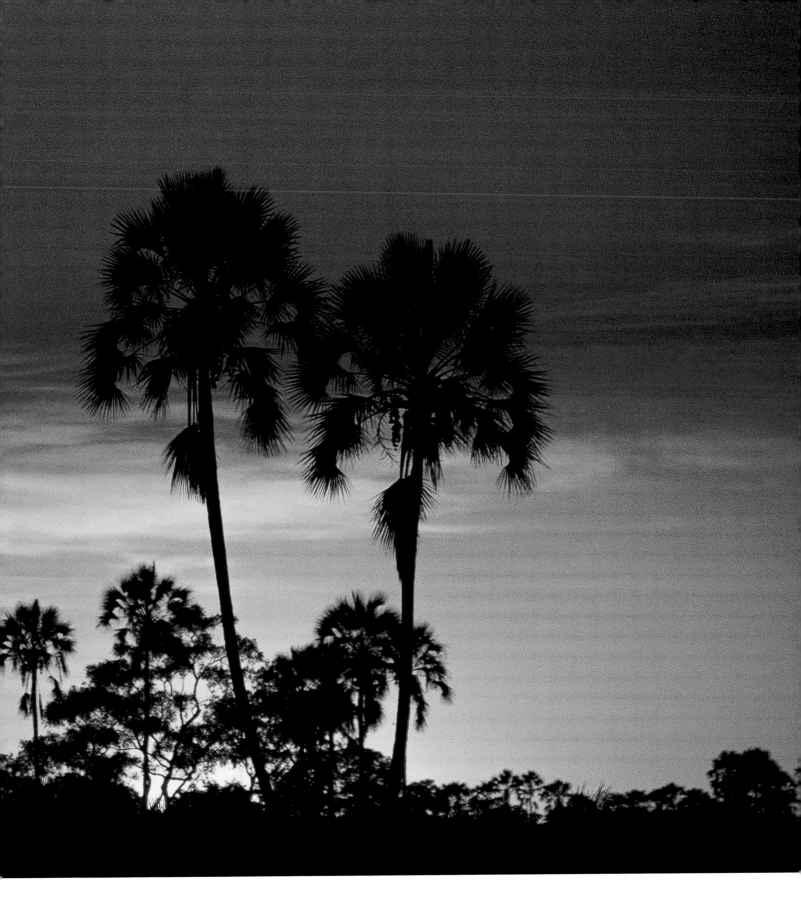

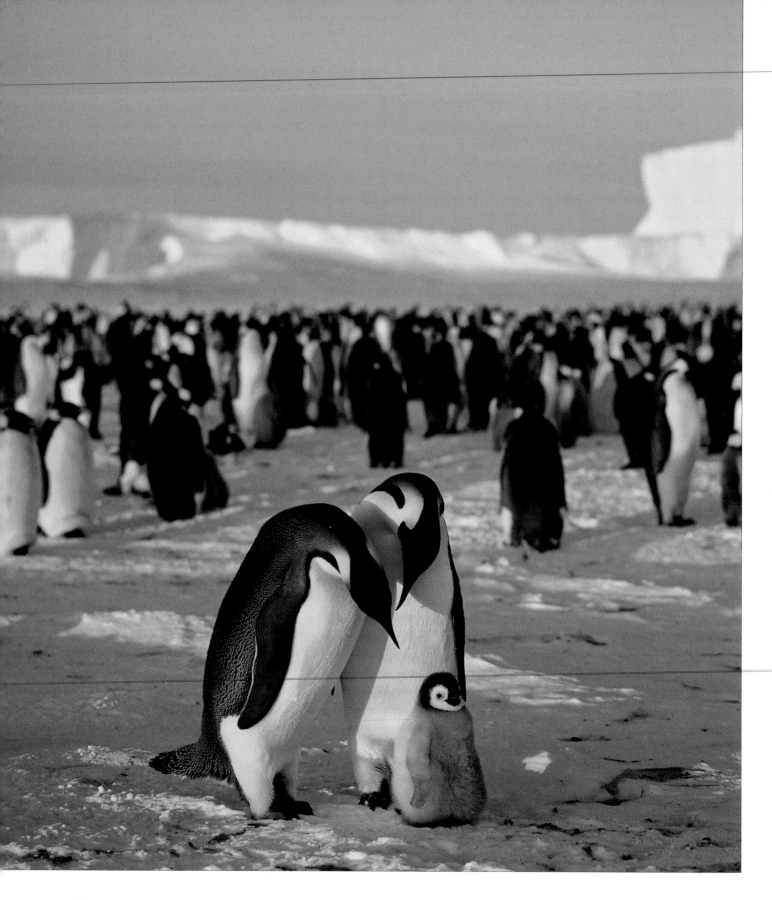

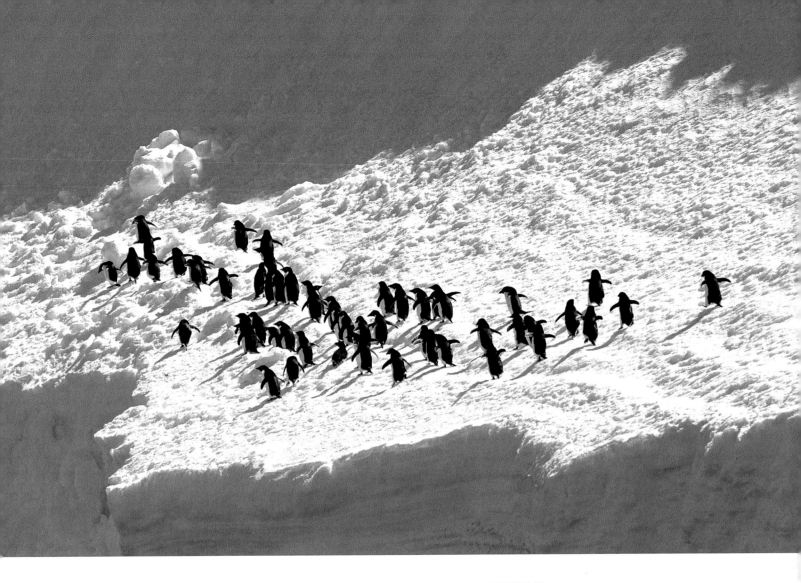

ANTARCTIC SUMMER

It is quite possible to photograph around the clock in the far south during the Antarctic summer, when the sun never sets. But the best time for modeling the largest of all penguins — the emperor — is when a low-angled sun casts long shadows across the ice. The sun and shadows belie the temperature, which was way below freezing at this time of the day.

Emperor penguins (*Aptenodytes forsteri*) at Atka Bay, Antarctica, November

Camera: Hasselblad 500CM
Lens: 150mm
Film: Ektachrome 100 Plus

PENGUIN PATTERNS

The tonal contrast and graphic shapes of black penguin backs marching over snow-covered ice, framed by blue shadow areas, was what attracted me to this scene. Before I could set up a camera, the penguins turned and began to retrace their steps, presenting me with white fronts against white ice! I was afraid that I had lost the best picture of the day; fortunately, the birds suddenly turned about again, and I was able to take the shot I had originally seen.

Adélie penguins (*Pygoscelis adeliae*),
Laurie Island, South Orkneys, Antarctica, November

Camera: Nikon F4; Lens: 500mm
Film: Ektachrome 100 Plus

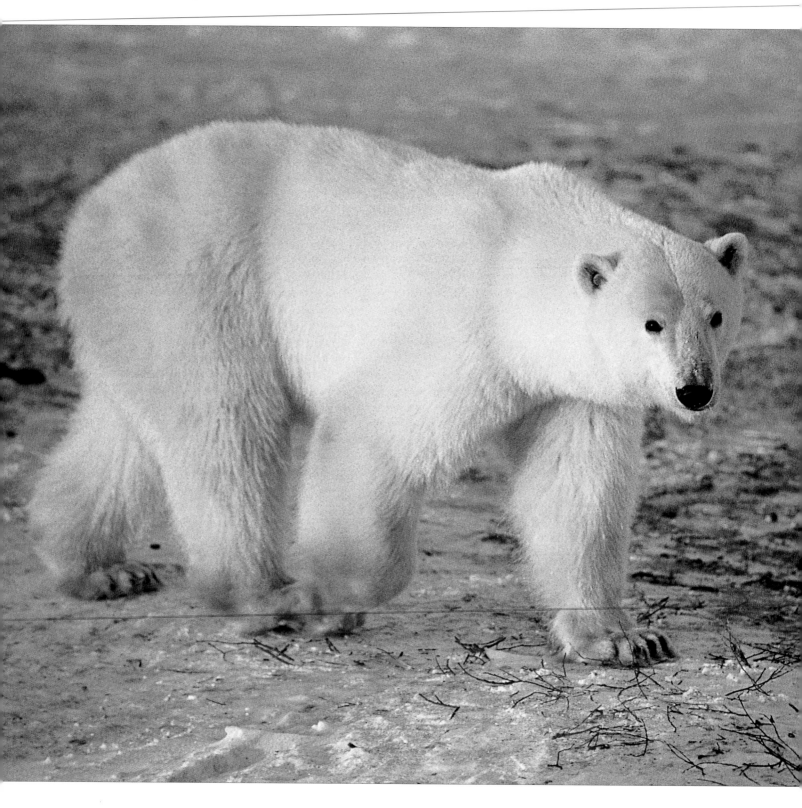

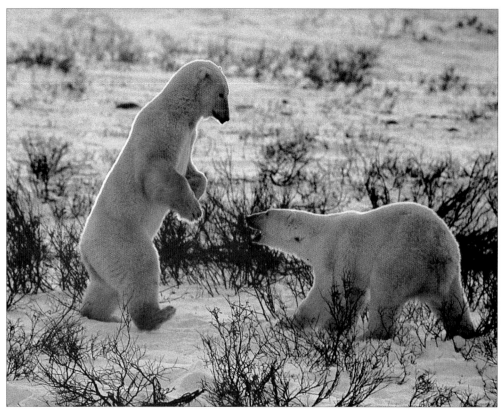

POLAR BEARS AT DUSK AND DAWN

By early November, the days are drawing in at Cape Churchill —
the polar bear capital of the world — but this is the prime time of
year to photograph the bears waiting for the sea to freeze. As the
sun dropped toward the horizon, it painted a bear and the ice with
a glorious golden light. Early one morning it rose as a golden orb,
to rimlight two bears beginning to play-fight on the tundra.

Polar bears (*Ursus maritimus*),
Cape Churchill, Manitoba, Canada, November

LEFT: At dusk; Camera: Nikon F3 with cold-weather battery pack
Lens: 300mm; Film: Kodachrome 200
ABOVE: At dawn; Camera: Nikon F4; Lens: 300mm
Film: Kodachrome 200

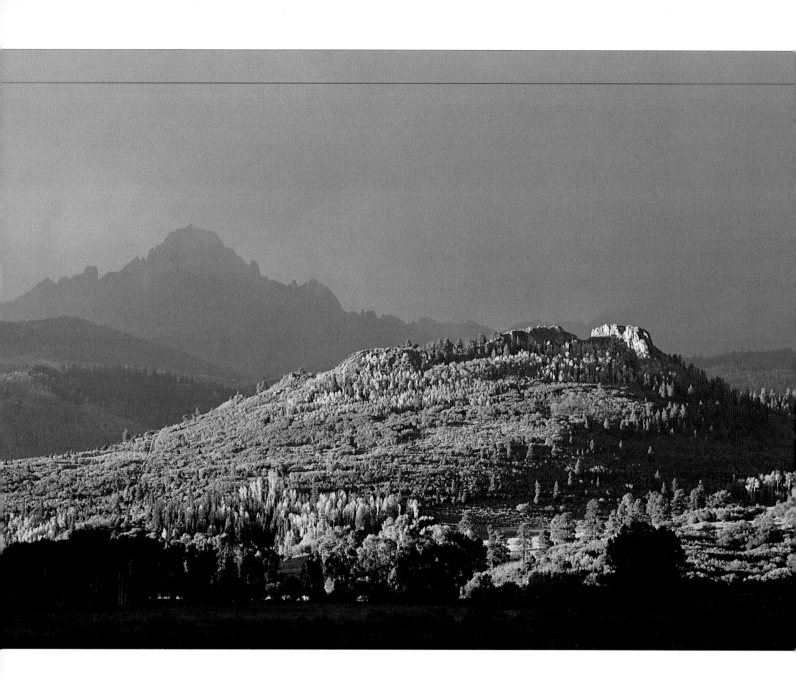

STORM PRELUDE

After an hour's drive to get the early morning light bathing fall-clad hills, I was dismayed to find dark storm clouds approaching. It was a race against time to unpack my gear before the clouds closed in completely, but those brief moments before the storm broke gave me wonderful dramatic lighting, with a sunlit hill rising up from a foreground in shadow and a leaden sky behind.

Thunderclouds approaching Mount Sneffels, Colorado, USA, September

Camera: Nikon F5; Lens: 80–200mm
Film: Ektachrome 100S

PRECISE CROP

Visiting Colorado's San Juan Mountains specifically for the fall colors, I had framed the picture in my mind before leaving the vehicle. Instinctively, I reached for a 80–200mm lens and moved toward the hillside, holding the camera vertically to echo the natural, upright growth of the trees. I love the way the glowing, backlit zigzag line of aspens contrasts with the dark green conifers.

Mixed forest, San Juan Mountains, Colorado, USA, September

Camera: Nikon F5
Lens: 80–200mm
Film: Ektachrome 100S

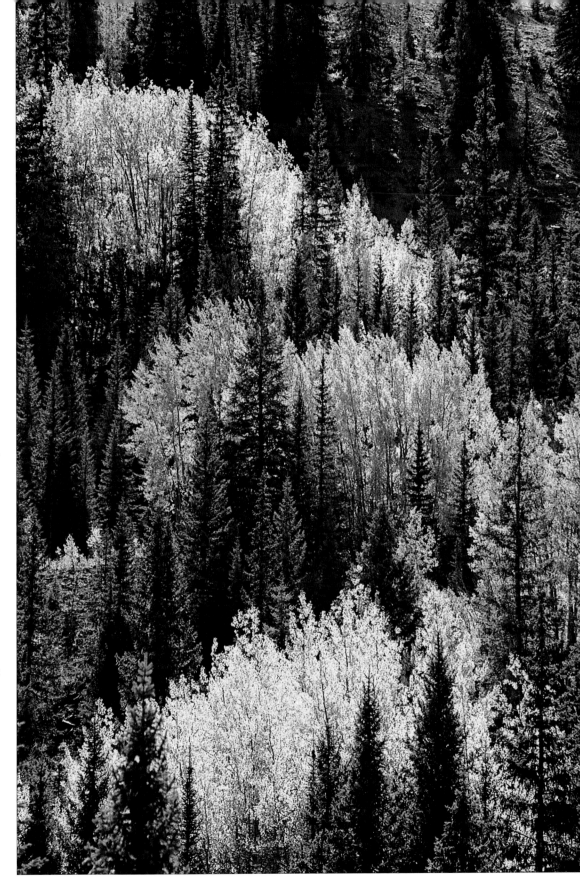

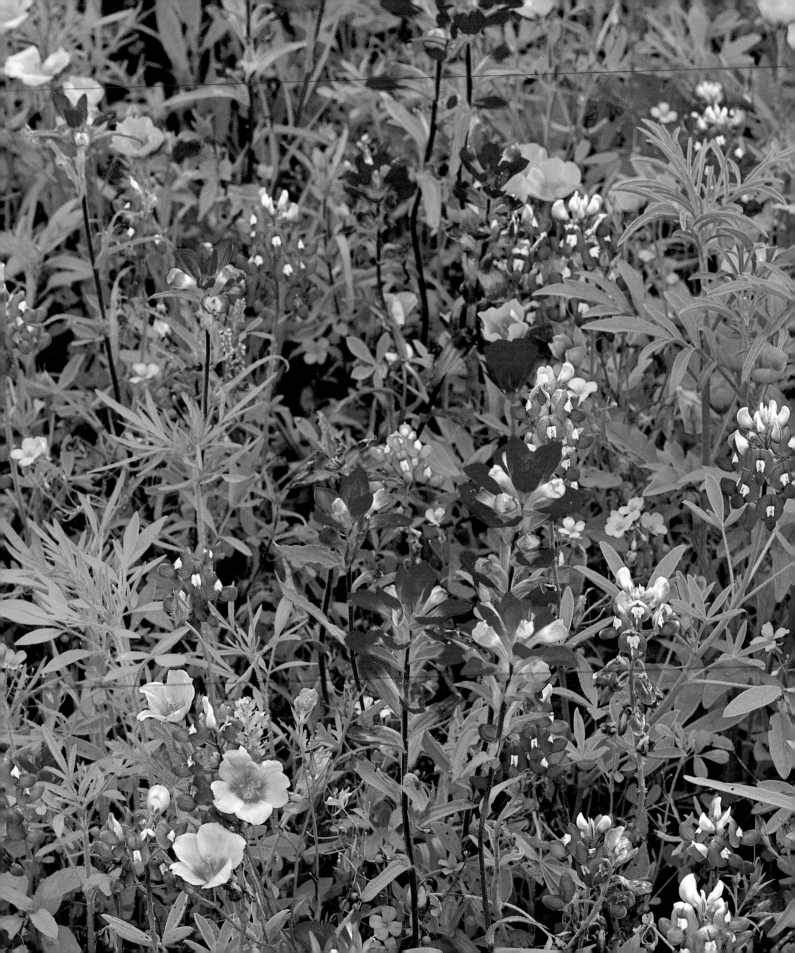

Plants on Location

THE EPHEMERAL NATURE of perfect blooms — some last only a matter of hours — makes it a real challenge to predict their appearance with any degree of certainty. Fall foliage is also short-lived, and once past its peak the next photo opportunity will be a year later. Unlike mammals and birds, plants do not display dramatic behavior, so more effort has to be invested in appraising the best specimens, the optimum lighting, and the most suitable crop, to arrest attention. It is disheartening to have to reject a particular plant because it is damaged, or the lighting is inappropriate, but from a photographic point of view it makes sense to be brutally critical. Plants are an essential element of life on earth, and deserve more attention from outdoor photographers.

FLORAL FEAST

If enough rain falls at the right time to trigger germination of the annual flowers, Texas in spring is nothing short of spectacular. Using a small pair of steps to gain extra height, I photographed this kaleidoscope of floral color in a quiet roadside ditch for several hours.

Wildflowers near Cuero, Texas, USA, April

Camera: Hasselblad 501CM; Lens: 120mm
Film: Ektachrome 100S

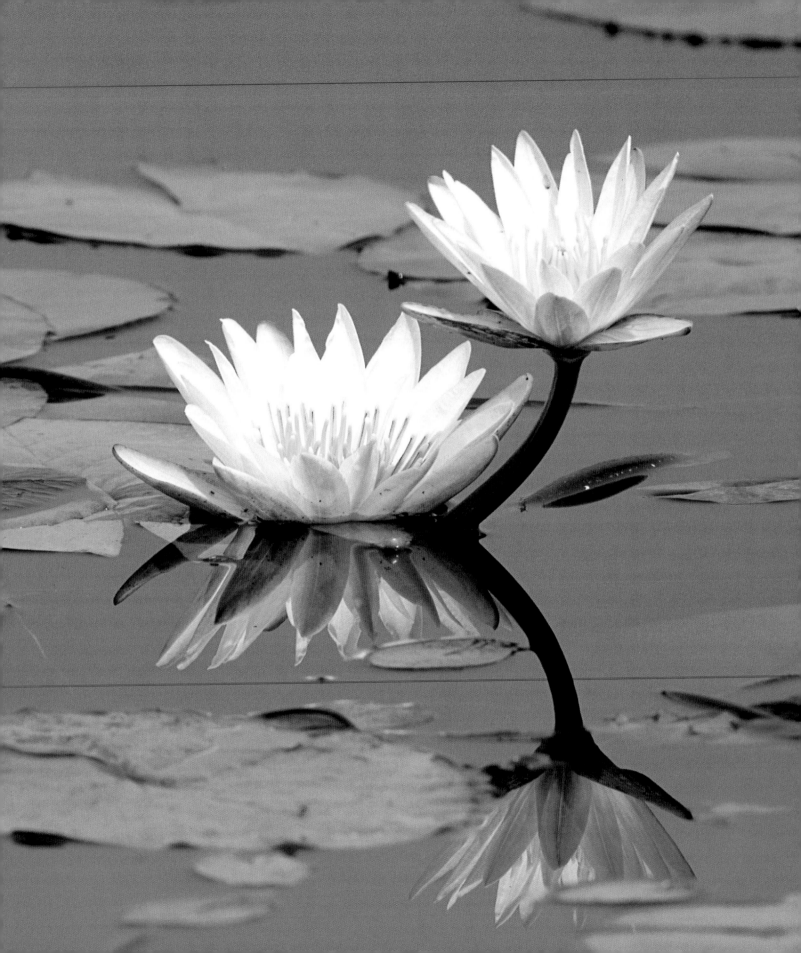

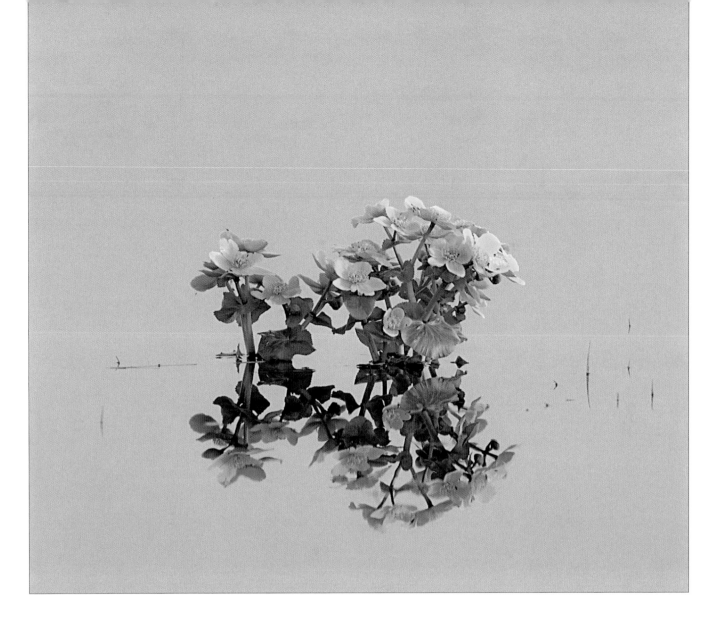

AQUATIC JEWELS

Any patch of water bedecked with blooming water lilies has a magnetic attraction for me. To capture the quintessential quality of these pastel-tone flowers, I had to wade out into the water; only after I had pushed the tripod legs firmly into the soft mud did I return for the camera. I tried a 300mm lens, but had to return for a 500mm in order to fill the frame.

Blue water lilies (*Nymphaea nouchali* var. *caerulea*), Moremi Game Reserve, Okavango Delta, Botswana, August

Camera: Nikon F4; Lens: 500mm; Film: Ektachrome 100S

MIRRORED SURFACE

Pastures temporarily flooded by snow-melt water create ideal conditions for marsh marigolds to flourish. Instead of appearing as yellow ribbons bordering streams and pools, here the flowers erupt through a uniform sheet of water. As I waded out to photograph the flowers, I generated ripples that temporarily distorted the perfect reflection. I waited for them to subside before taking the shot.

Marsh marigolds (*Caltha palustris*), Biebrza Marsh, Poland, April

Camera: Nikon F5; Lens: 500mm; Film: Ektachrome 100S

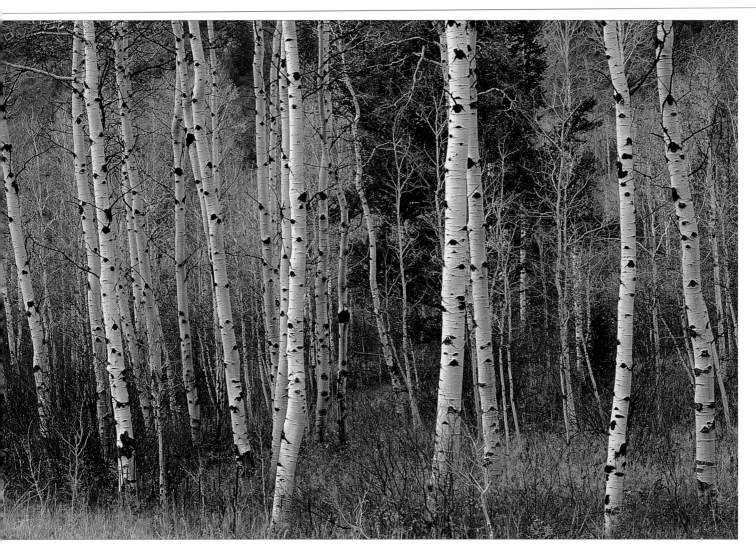

ASPEN GROVE

The pallid bark of aspen trunks punctuated with the dark, triangular scars of fallen branches works equally well in monochrome or color. On an overcast day I used a $^1/_2$-second exposure to gain a reasonable depth of field. By cropping out the crowns of the trees, attention is focused on the bare trunks, with the ghostly outlines of young saplings receding into the distance.

Quaking aspen (*Populus tremuloides*) trunks, Wyoming, USA, October

Camera: Nikon F4; Lens: 80–200mm; Film: Kodachrome 25

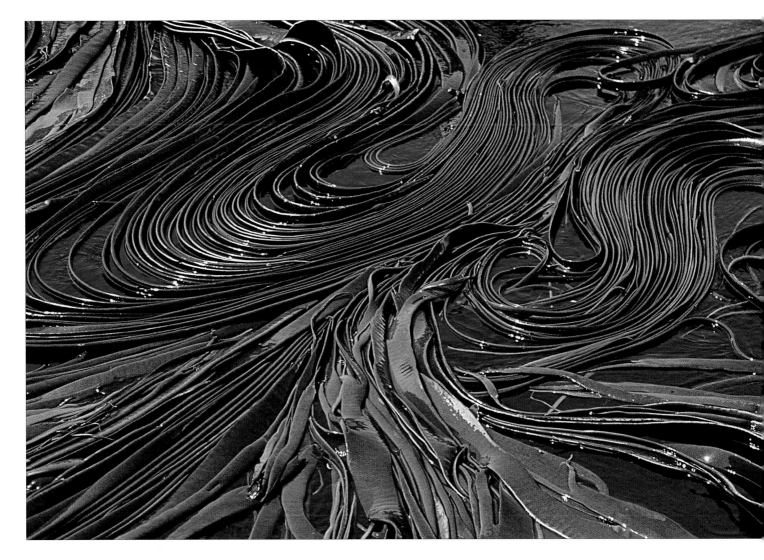

SINUOUS SEAWEED

After taking photographs of fur seals on a rocky shore in New Zealand, I noticed sinuous bull-kelp fronds buoyed up by the rising tide. The contrast between the khaki-colored seaweed and the deep blue water was irresistible. I became mesmerized as the weeds swished back and forth, repeatedly changing their configuration with the result that no two frames were identical.

Bull-kelp (*Durvillea antarctica*) in sea, near Dunedin, New Zealand, December

Camera: Nikon F4S; Lens: 300mm; Film: Ektachrome 100 Plus

PAINTERLY POPPIES

A field brimming with red poppies always has a very strong attraction for me, yet each successive year it becomes harder to find a new angle. Here, a 500mm lens helped to compress the red foreground and render the misty trees as a painterly impression. By the time I had taken a complete roll, the sun had burned off the mist and the soft light had vanished.

Poppies (*Papaver dubium*) in flax field, Surrey, England, July

Camera: Nikon F4; Lens: 500mm
Film: Ektachrome 100S

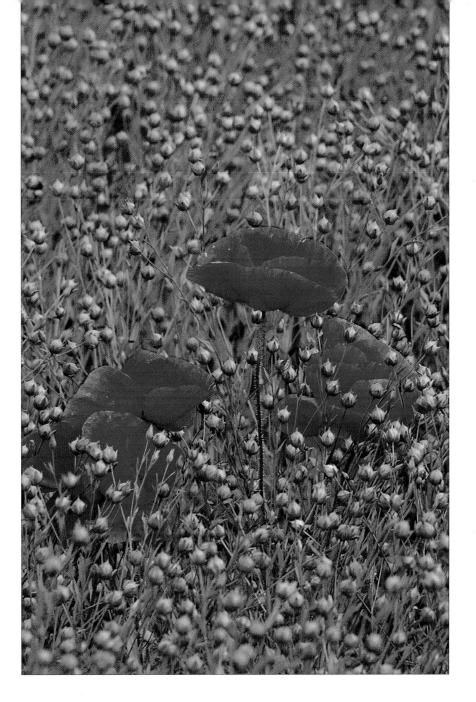

COLOR CONTRAST

Later I moved to the fence bordering the field, using a stepladder to gain height. It was the luminosity of a clump of red blooms rising above a green sea of seeding flax heads that attracted me, and I framed this shot with a shorter-length telephoto lens. Even then I had not exhausted the site, which I photographed for another hour.

Poppies (*Papaver dubium*) amongst seeding flax crop, Surrey, England, July

Camera: Nikon F4; Lens: 300mm; Film: Ektachrome 100S

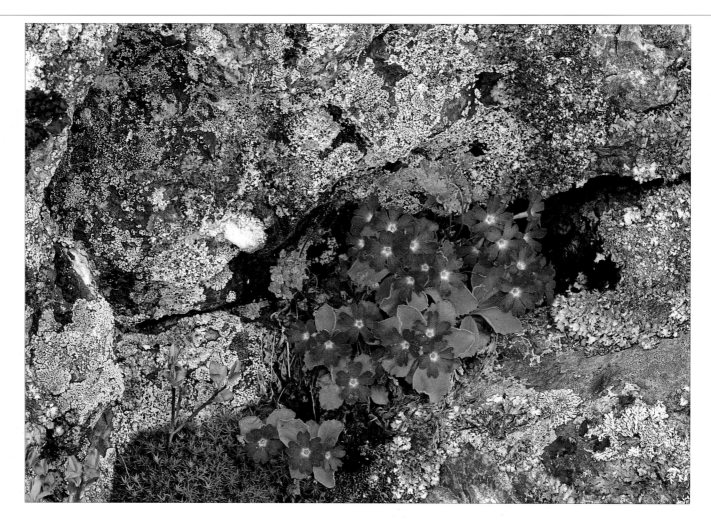

ACCENT ON COLOR

My initial disappointment at finding that every clump
of red alpine primroses was past its prime made me
determined to look more thoroughly. Leaving my gear on
top of a rock, I systematically searched shady rock crevices,
and was rewarded with late-blooming pink flowers nestling
against a lichen-covered rock. I used fill-flash to add a little
sparkle to this attractive alpine cameo.

Red alpine primrose (*Primula hirsuta*),
Col de Portalet, Spanish Pyrenees, April

Camera: Nikon F5; Lens: 105mm Micro-Nikkor
Film: Ektachrome 100S; Flash: SB 26 less 2 stops

TRACKING THE SUN

Sunflowers always face the same direction because the heads
track the sun. After taking a clump of nodding sunflowers
frontlit at first light (which was used to produce the
digitized art image on page 120), I turned around 180
degrees to shoot through the backs of the flowers. I really
liked the contrast between the opaque green sepals and the
apparent coronets of translucent yellow petals.

Nodding sunflowers (*Helianthella quinquenervis*),
near Crested Butte, Colorado, USA, July

Camera: Nikon F4; Lens: 80–200mm
Film: Ektachrome 100S

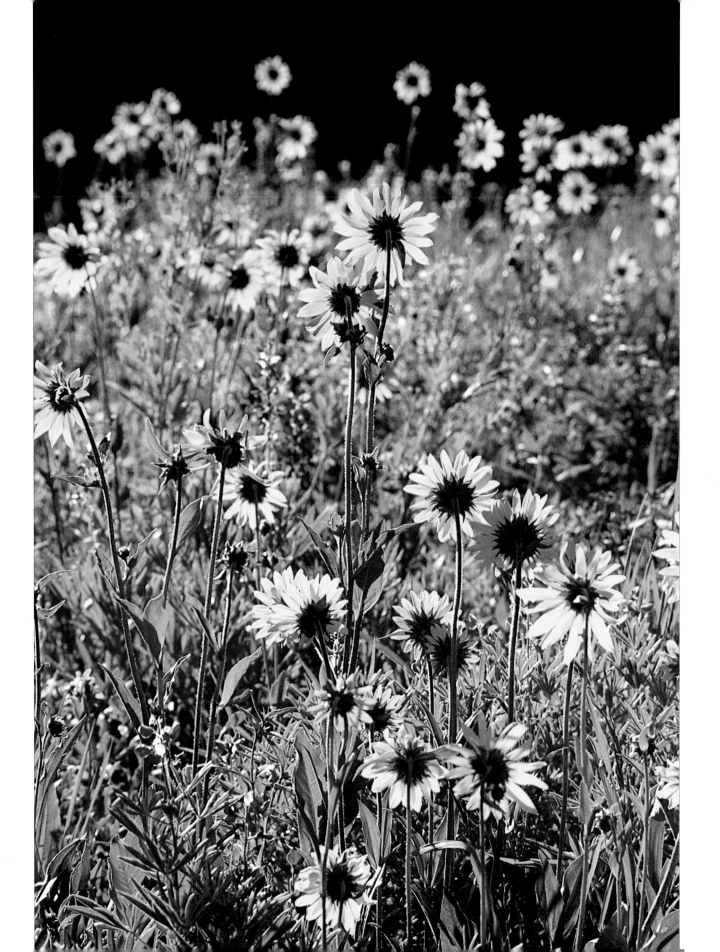

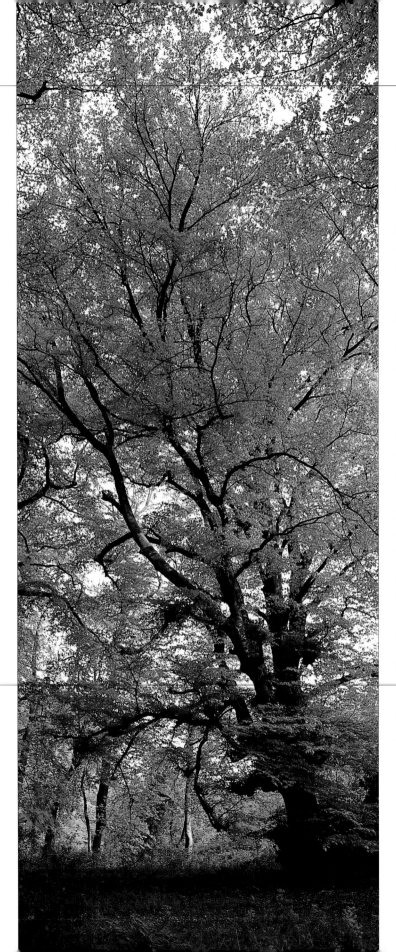

TOWERING BEECH

A mature beech tree reaching for the sky in a wood above the house of Gilbert White, the eighteenth-century naturalist, was a perfect subject for framing as a vertical format with a panoramic camera. With such a wide exposure range, from the dark, unlit ground to the bright sky between the branches, I spot-metered the densest green foliage in the upper third of the frame, which turned out perfectly.

Beech tree (*Fagus sylvatica*),
Selborne, Hampshire, England, May

Camera: Hasselblad XPan; Lens: 45mm
Film: Ektachrome 100S

GLOWING SUGAR MAPLE

On my way to photograph sockeye salmon, I passed sugar maples, which glowed more visibly with each successive day. From past experience I knew that a gale could suddenly destroy all the color, but it was always dark by the time I returned. When persistent rain called a halt to the salmon shoot, I checked out the maples, which I took with a 500mm lens to fill the frame with the tree, and double-rated the film speed to increase the color saturation of the foliage.

Sugar maple (*Acer saccharum*), near Salmon Arm, British Columbia, Canada, October

Camera: Nikon F5; Lens: 500mm
Film: Ektachrome 100S rated at 200 ISO

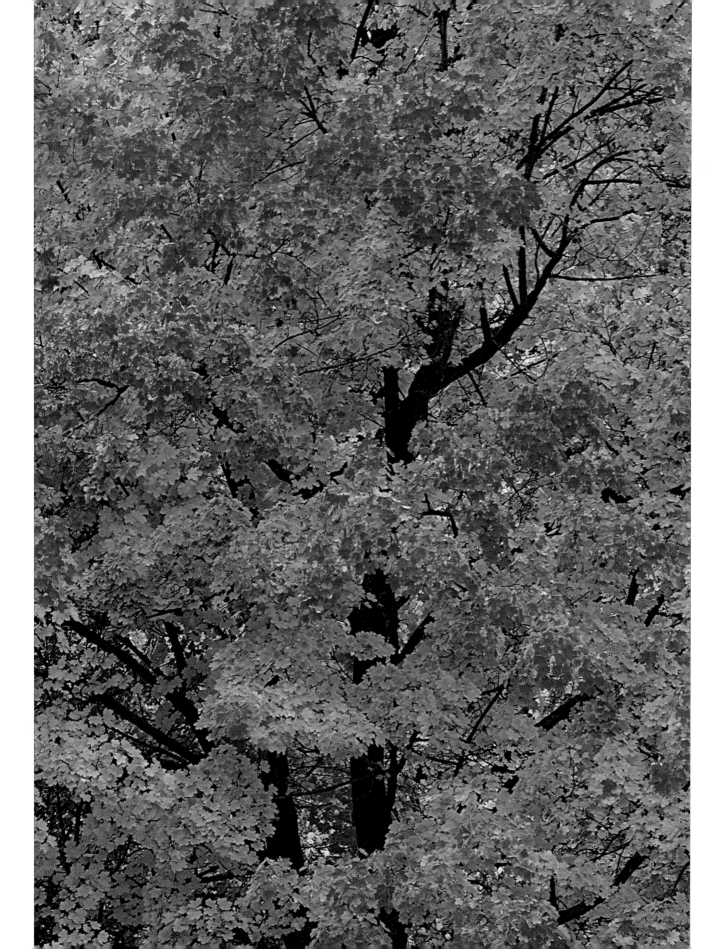

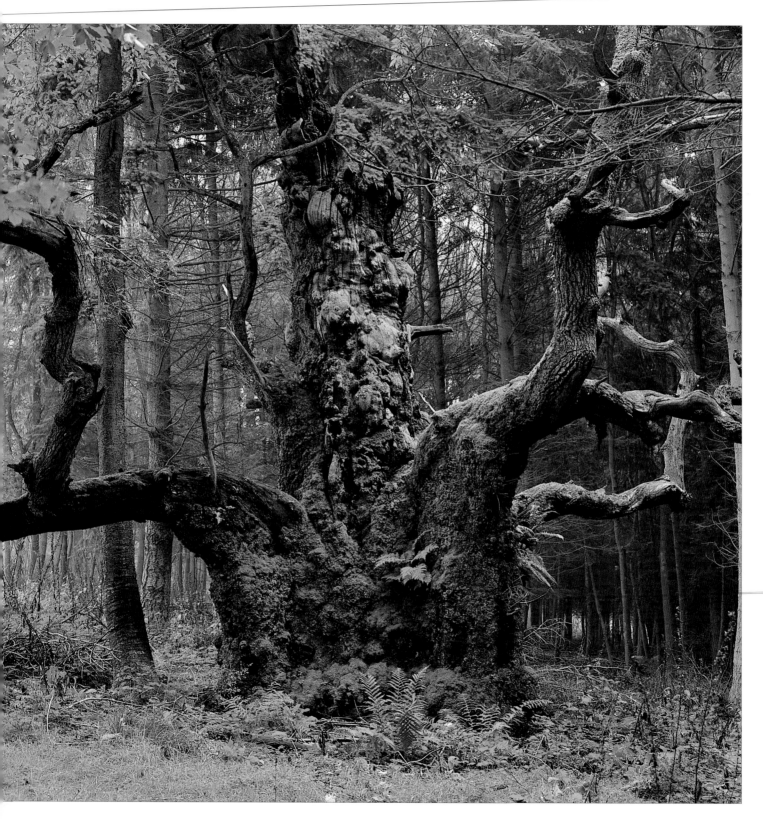

VETERAN OAK

This ancient oak tree on an old estate bordering
England and Wales is now bereft of a leafy canopy,
but still supports a rich array of epiphytic mosses and
lichens on its trunk and wizened boughs. To emphasize
the primeval nature of this veteran, I chose a tight
crop with a medium format.

Veteran oak tree (*Quercus robur*),
Croft Castle, Herefordshire, England, October

Camera: Hasselblad 500CM; Lens: 150mm
Film: Ektachrome 100 Lumière

ISLAND FLORA

Like other Southern Ocean islands, Campbell Island is
noted for large-leafed plants, the so-called megaherbs.
Constant buffeting by winds blowing across the ocean
prunes the trees on the island into a stunted, elfin
forest, and I wanted to show both the outsize megaherb
leaves and the distorted, lichen-clad trunks in the same
picture. The color of the leaves, as well as that of the
lichens, became enriched after a rain shower.

Megaherb (*Pleurophyllum speciosum*) outside elfin
forest, Campbell Island, Southern Ocean,
Antarctic realm, December

Camera: Nikon F4; Lens: 80–200mm
Film: Kodachrome 200

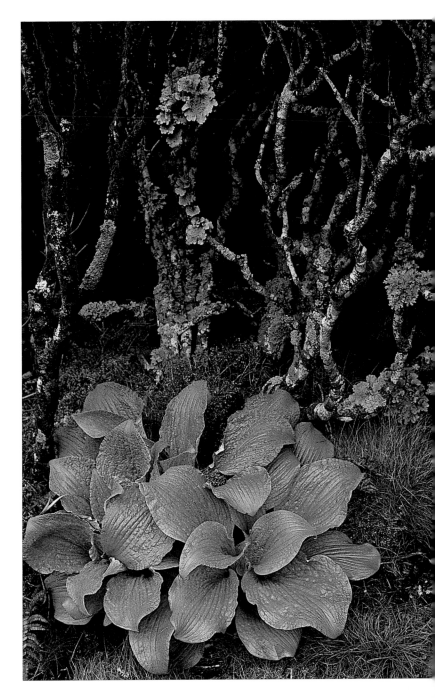

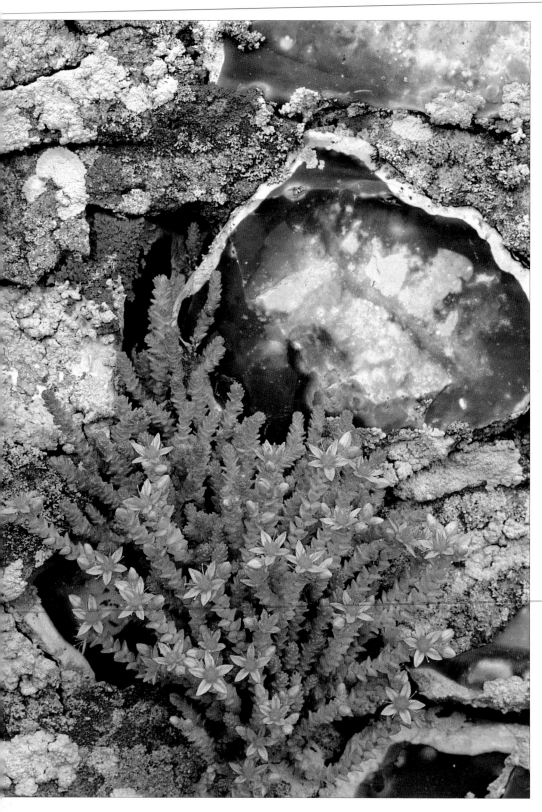

STONECROP

The yellow, star-shaped stonecrop flowers and green succulent stems added a touch of color to a lichen-encrusted, gray-flint wall bordering a village lane. The stonecrop stems growing up around the left edge of the sectioned flintstone led the eye upward and suggested a vertical format here.

Biting stonecrop (*Sedum acre*) on wall, Hampshire, England, June

Camera: Nikon F4
Lens: 105mm Micro-Nikkor
Film: Ektachrome 100 Plus

MOUNTAIN GARDEN

Colorado's mountains in summer are a plant photographer's dream. Here, however, it was not the flowers themselves that attracted me, but the textured cornhusk lily leaves and the way the upper triangular clump dovetailed so neatly with the bluebells below and to the left.

Cornhusk lily leaves (*Veratrum tenuipetalum*) with mountain bluebells (*Mertensia ciliata*), Yankee Boy Basin, Colorado, USA, July

Camera: Hasselblad 501CM
Lens: 120mm
Film: Ektachrome 100S

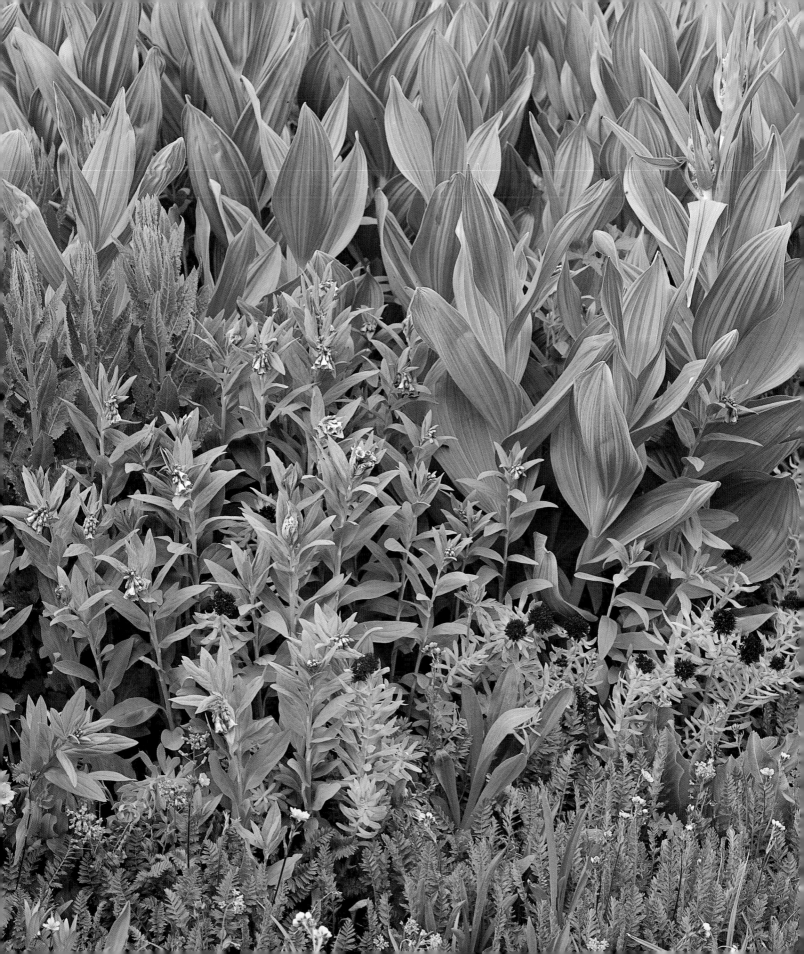

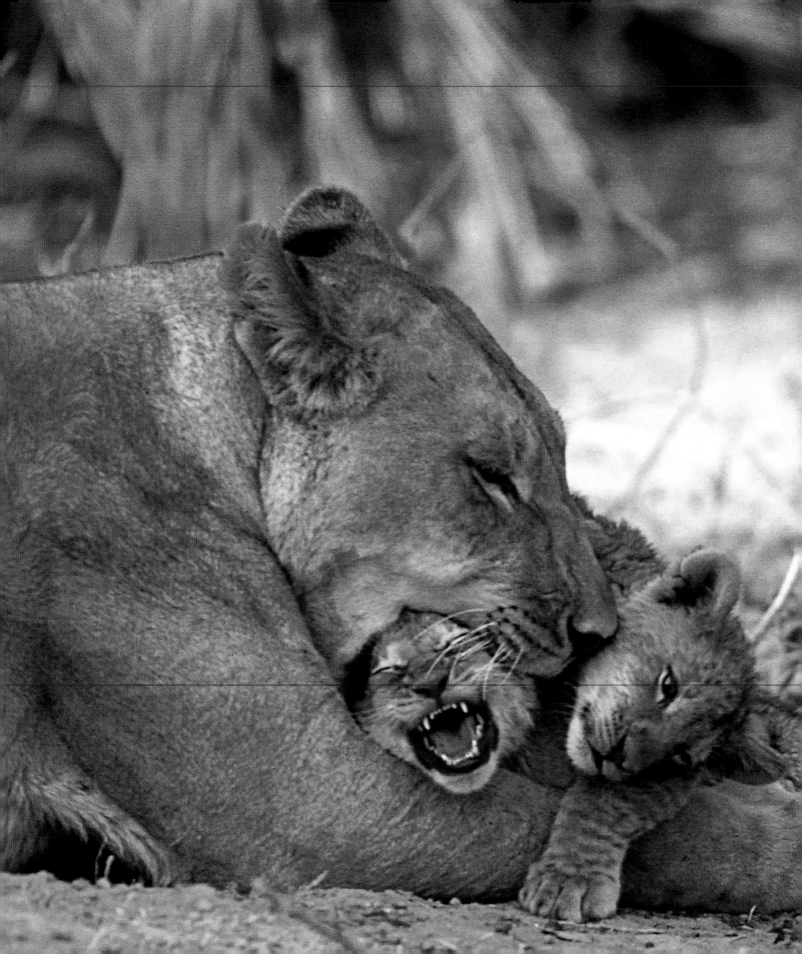

Wilderness Wildlife

WILDLIFE PHOTOGRAPHY IS always a challenge, whether it involves working close to home or traveling to a remote location. Succeeding as a wildlife photographer is not simply a question of investing in a large telephoto lens and using it to take every subject in sight. Without a doubt, the prime factor is a love and knowledge of the subject, combined with considerable patience and a fair amount of luck, as well as a determination to succeed. The unpredictable nature of wild and free animals, together with the element of risk involved when working with potentially dangerous mammals, provides an undeniable thrill and a great sense of satisfaction if the shot is captured. Even when not actually taking pictures, there is the bonus of experiencing a wilderness situation and anticipating the animals' next moves.

CUB CONTROL

Within a few minutes of landing on a bush airstrip I encountered a lion family, with tiny cubs frolicking all over their mother. When she restrained one by gently gripping it in her mouth, the cub protested with a vivid facial expression, in contrast to that of its relaxed sibling.

Lioness (*Panthera leo*) with cubs, Moremi Game Reserve, Okavango Delta, Botswana, August

Camera: Nikon F4S; Lens: 500mm; Film: Ektachrome 100S

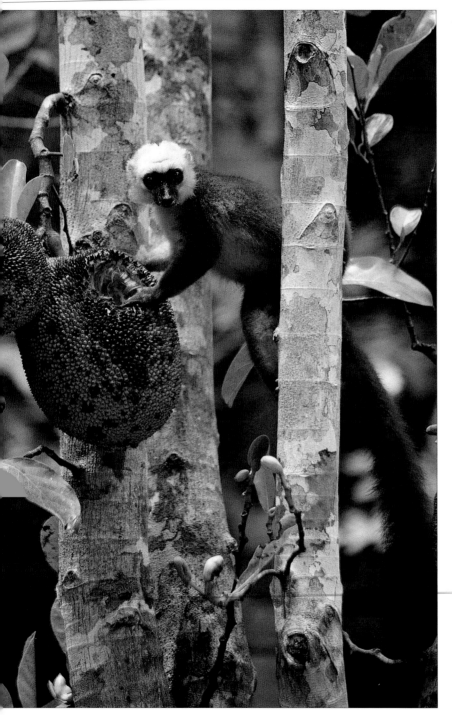

JACKFRUIT RAIDER

Ripe fruits have a magnetic attraction for wildlife, so it pays to lie in wait for opportunistic shots. Throughout the day, a succession of lemurs visited this jackfruit on a small Malagasy island. By setting up a camera with a long lens on a tripod, I only had to fine-tune the focus when a lemur moved into the shot.

White-fronted brown lemur (*Eulemur fulvus albifrons*) feeding on jackfruit,
Nosy Mangabe, Madagascar, October

Camera: Nikon F4; Lens: 500mm
Film: Kodachrome 200

LOFTY PERCH

Initially I used a longer lens to crop in tightly on the young panda sitting in the fork of this tree. But it didn't take long for me to appreciate that by pulling out with a wider lens to reveal the youngster surveying the snow-clad forest from its lofty perch, I had a picture with much greater impact.

Young giant panda (*Ailuropoda melanoleuca*),
Wolong Reserve, Sichuan Province, China, January

Camera: Nikon F4; Lens: 35–70mm
Film: Ektachrome 100S

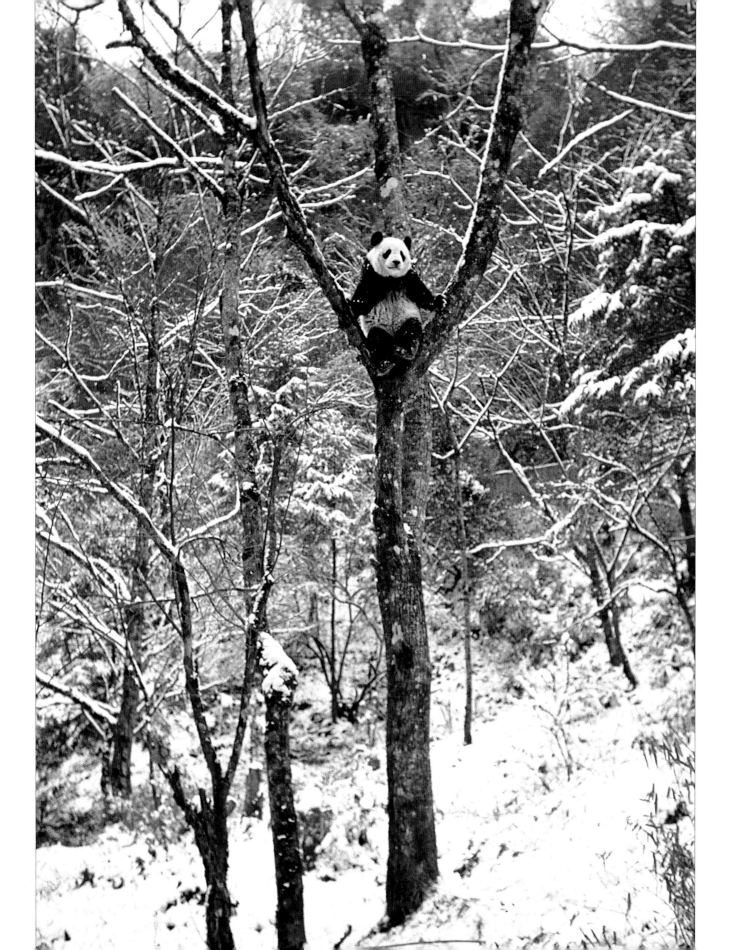

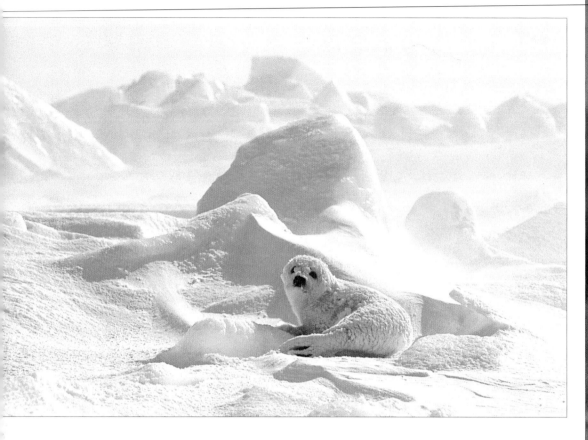

ICE CRADLE

Icy shards stung my face as I emerged from a helicopter onto pack ice. An overnight blizzard had camouflaged harp seal pups so efficiently that they merged in with the ice. When a head rose up from the ice and a pair of soulful, black eyes blinked at me through the blizzard, I was galvanized into action. I used a camera with a remote battery pack and a zoom lens with a deep lens hood to keep the snow off.

Harp seal pup (*Phoca groenlandica*) on pack ice, Gulf of Saint Lawrence, Canada, March

Camera: Nikon F3 with remote battery pack
Lens: 80–200mm
Film: Ektachrome 100 Plus

MARSH FLIGHT

Swans flying over water are an everyday sight, but ever since I had read about the sheets of marsh marigolds in a Polish marsh, I had envisaged a shot of the white birds above the yellow carpet. Using a window mount inside a vehicle, I panned the swans flying low over the marsh. The strong diagonal line leading from the wing tip of one bird through the head, neck, and wing of the other was quite fortuitous.

Mute swans (*Cygnus olor*) over Biebrza Marsh, Poland, April

Camera: Nikon F5; Lens: 500mm
Film: Ektachrome 100S

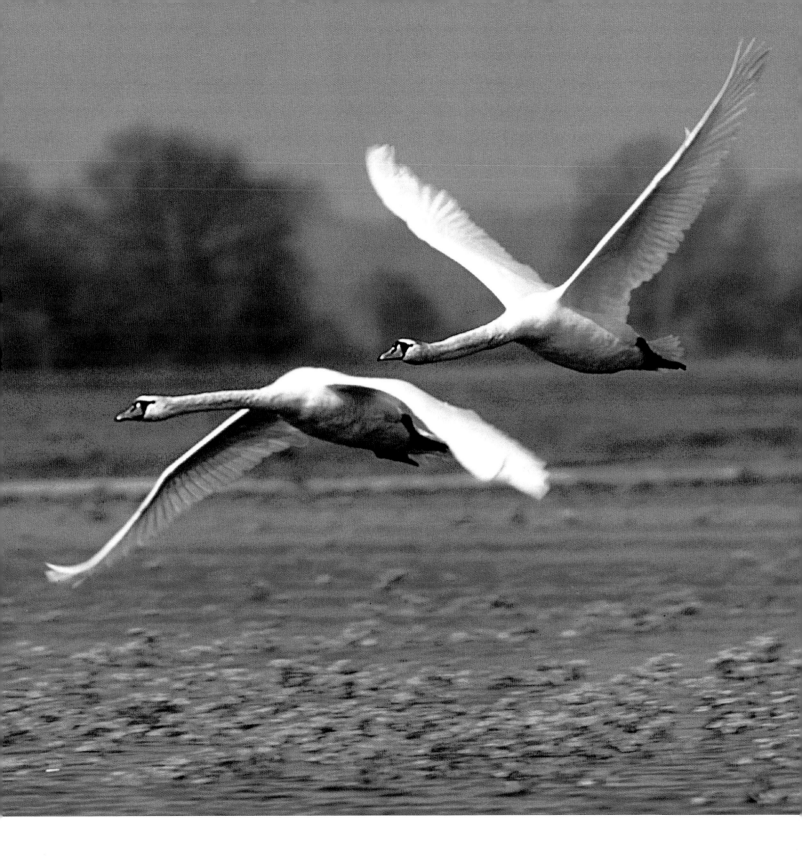

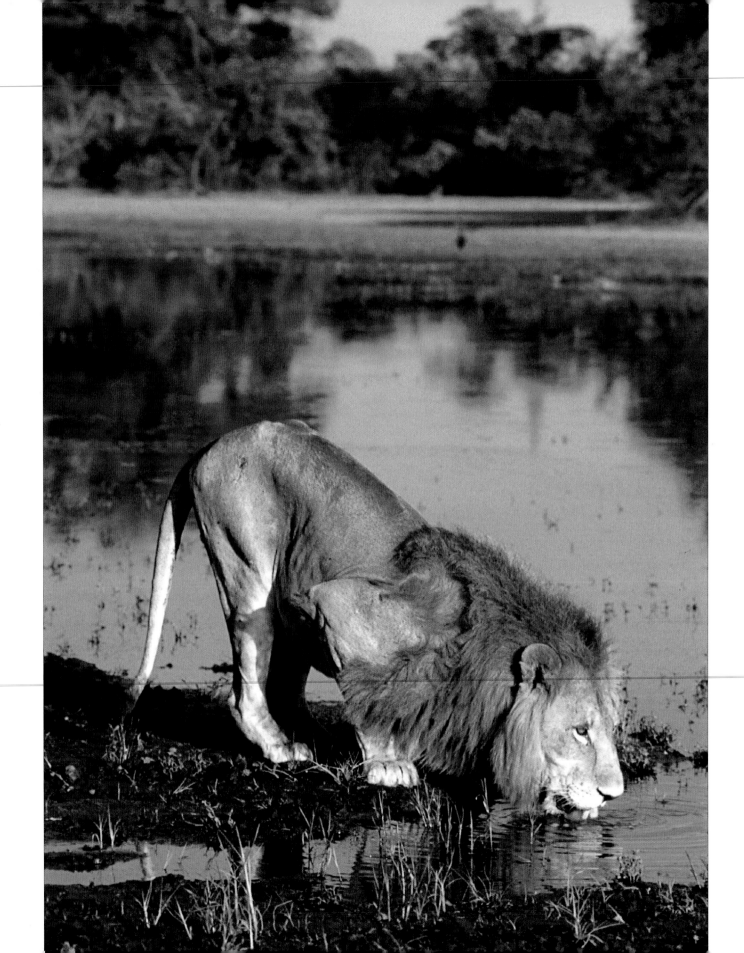

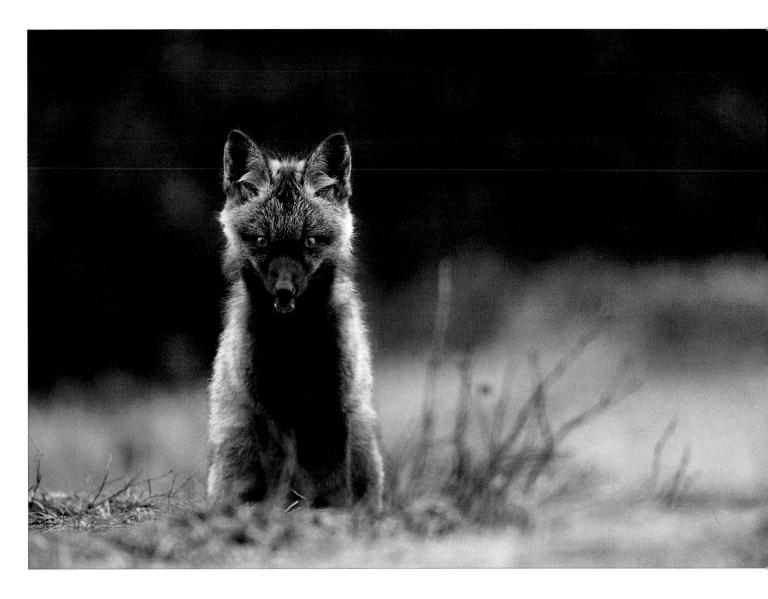

DRINKING AT DAWN

As I drove through a clearing into an open space with a water-filled pan, I found a lioness drinking, bathed in the warm glow of the first light. I took a few frames before she withdrew and this male appeared, which gave me time to recompose from a horizontal to a vertical format. Moments later they began to mate, and I took the picture on page 94.

Lion (*Panthera leo*) drinking, Moremi Game Reserve, Okavango Delta, Botswana, November

Camera: Nikon F4; Lens: 80–200mm
Film: Ektachrome 100S

SURPRISE ENCOUNTER

An early-morning walk up a track toward the snow line in summer paid dividends when I encountered a young fox. I was not sure which of us was more surprised. Certainly the youngster was curious enough to remain intently focused on me and my camera, so I could get this eye-to-eye shot. The pink tongue added color contrast to the somber coat.

Young fox (*Vulpes vulpes*), Mount Rainier National Park, Washington, USA, July

Camera: Nikon F4; Lens: 500mm
Film: Kodachrome 200

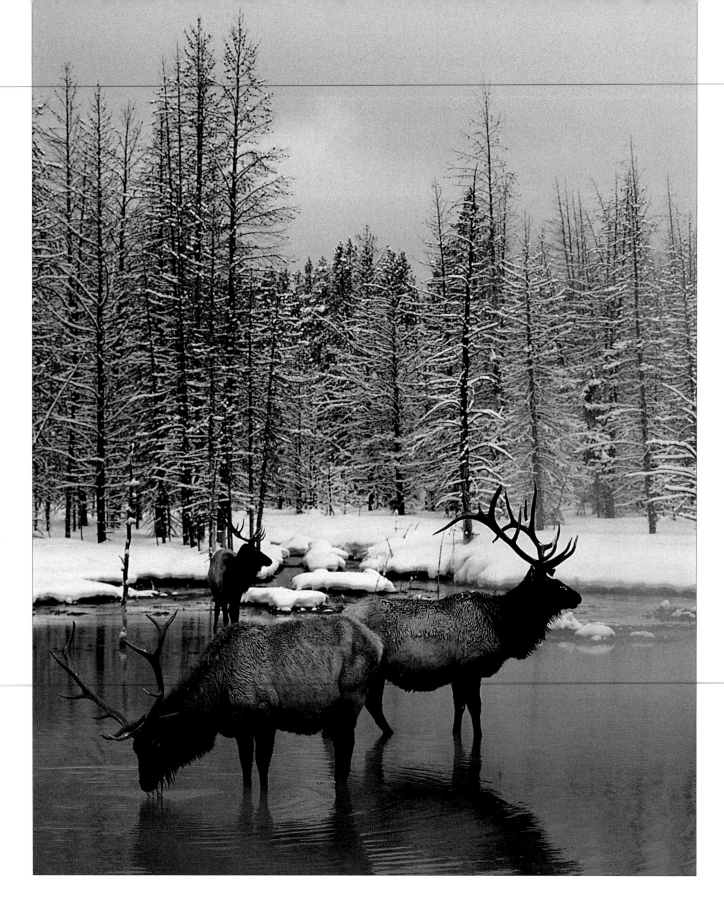

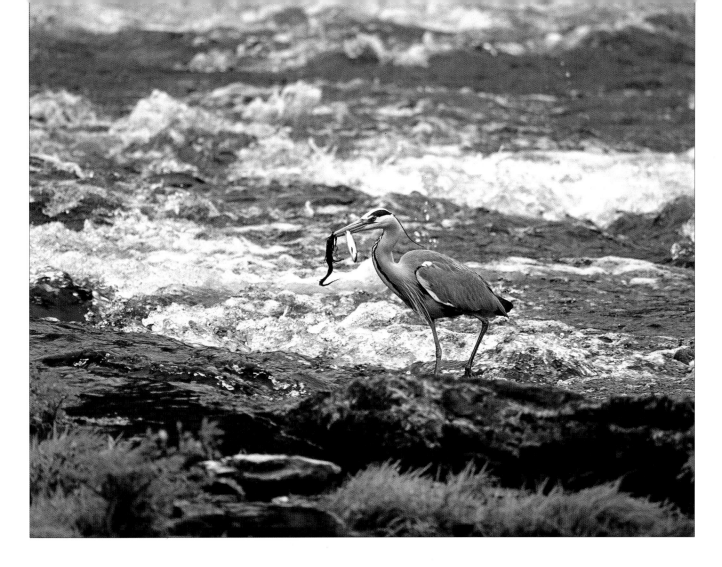

WINTER WATERING HOLE

Yellowstone in winter is full of contrasts. The deep snow that blankets much of the park is punctuated by bare patches, where active fumaroles induce localized snow-melt areas and warm-water inflows keep pools ice-free, allowing elk to drink. I began shooting three bull elk in a horizontal frame, but when one moved off into the forest I switched to a vertical format. Snow has helped to soften the charred skeletons of lodgepole pines burned by fires in 1989.

Bull elk (*Cervus canadensis*) drinking in pool,
Yellowstone National Park, Wyoming, USA, January

Camera: Nikon F4; Lens: 300mm
Film: Kodachrome 200

SNATCHING A MEAL

Whenever I drive along a country road adjacent to water, I keep an eye open for a heron out fishing. After spotting this bird standing above a weir, gazing at the turbulent water below, I pulled off the road to use the car as a blind. This idea was flawed by a fence beside a picnic area, so I had no option but to set off on foot. The heron was obviously used to people because it stayed put, and within moments it had plucked a fish (with some weed) from the river.

Grey heron (*Ardea cinerea*) fishing,
River Bandon, County Cork, Ireland, May

Camera: Nikon F5; Lens: 500mm
Film: Ektachrome 100VS

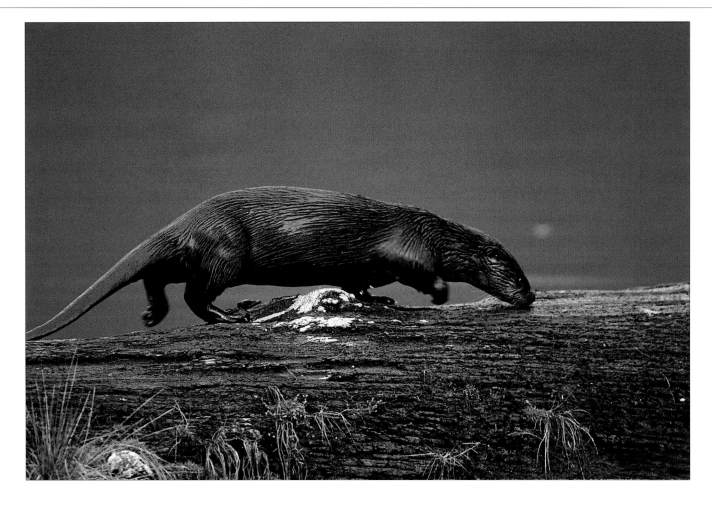

DAWN EXCURSION

I rose early in the hope of catching otters swimming. Periodically I saw a head emerge, only to vanish into the sea again. All I could do was prefocus the camera on a log lashed to my floating lodge and wait. I was rewarded by a sleek body — plastered with wet fur — racing back home. Even though I pushed an ISO 200 film by two stops, two of the feet appear slightly blurred.

River otter (*Lutra canadensis*) running along old trunk, Knight Inlet, British Columbia, Canada, October

Camera: Nikon F5; Lens: 500mm
Film: Ektachrome 200 rated at ISO 800

SPOTLIT LEOPARD

It was one of those early-morning game drives that became better by the moment. Before the sun had risen, we encountered a leopard sitting in our track and followed it at a distance, watching repeated scent-marking before it climbed a tree. As the leopard turned its head to the right, I got my shot when one eye became spotlit by a sunbeam piercing a gap in the branches.

Leopard (*Panthera pardus*) in tree, Moremi Game Reserve, Okavango Delta, Botswana, February

Camera: Nikon F5; Lens: 500mm
Film: Ektachrome 200

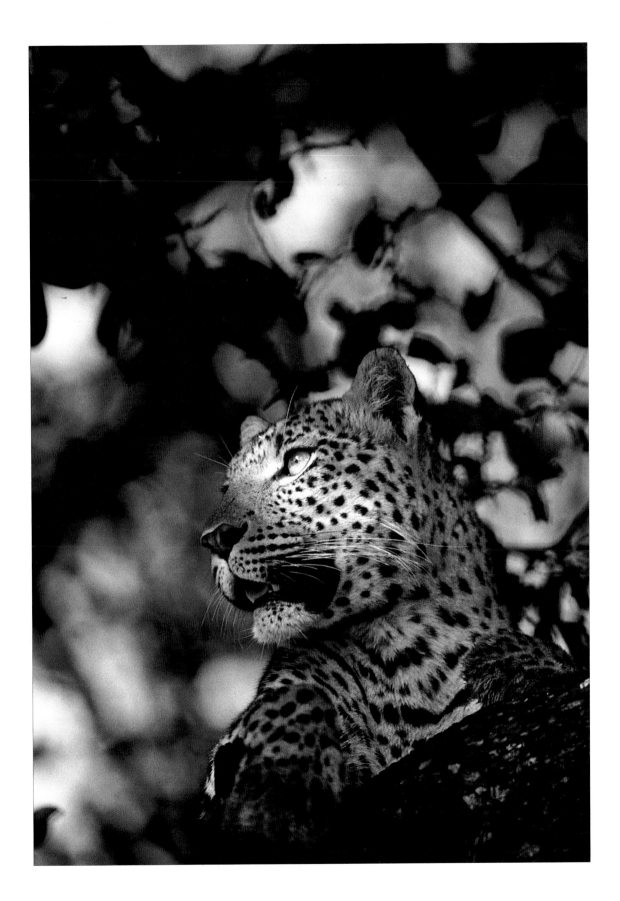

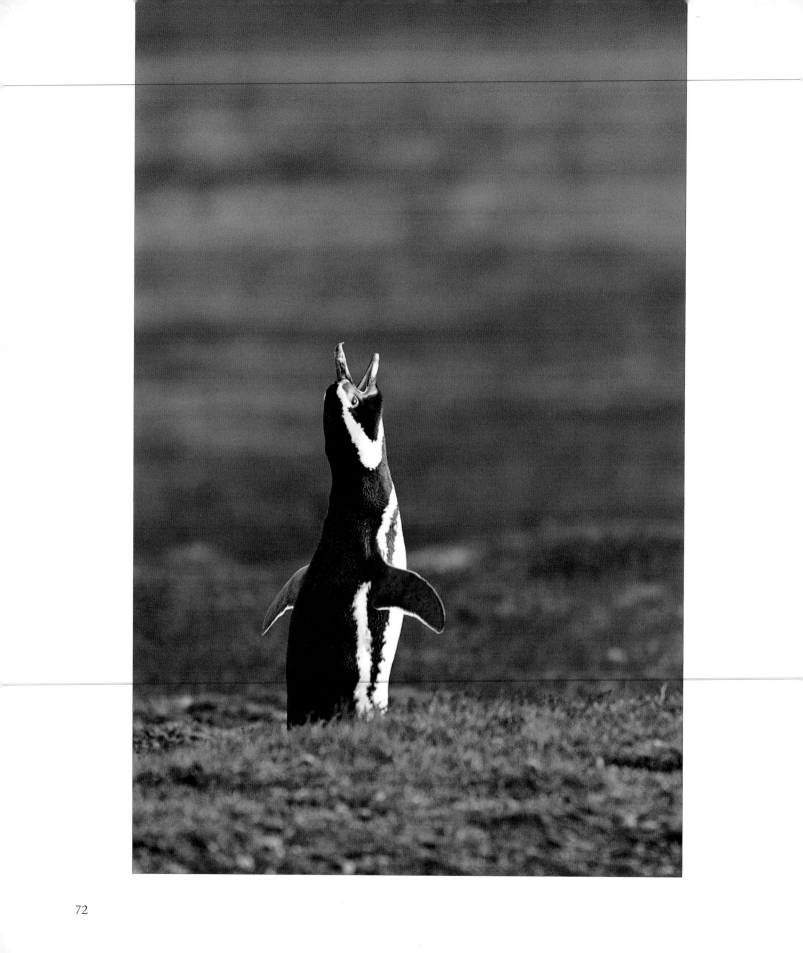

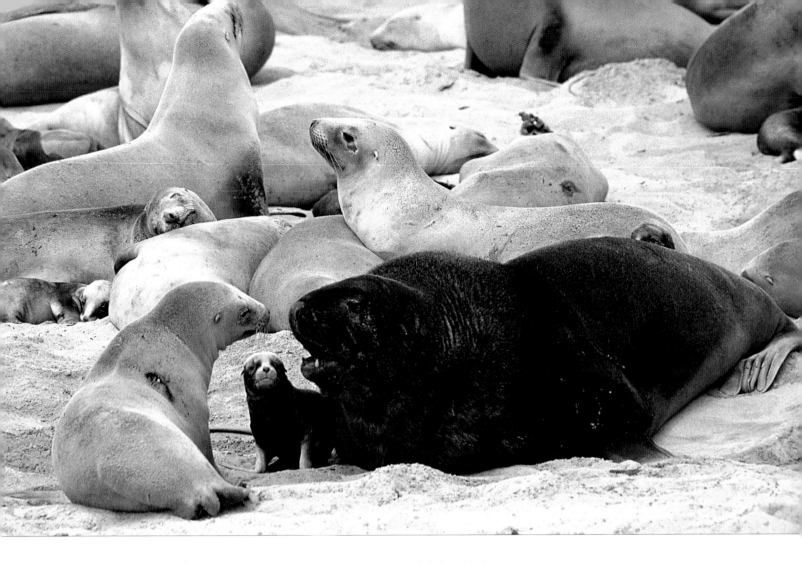

ECSTATIC DISPLAY

Magellanic penguins nest in burrows beneath the turf.
On a fine evening in the austral summer, a male emerges
at sundown to stake his claim to the burrow. He displays
with extended flippers, pointing his bill skyward to bray.
Even though penguins will tolerate a close approach on
the Falklands, I preferred to stand back and use a long
lens so that I could throw the red carpet of seeding
sorrel behind him out of focus.

Magellanic penguin (*Spheniscus magellanicus*) calling,
Sea Lion Island, Falkland Islands, November

Camera: Nikon F4; Lens: 500mm
Film: Ektachrome 100S

PARENTAL PRIDE

When not sleeping, all sea lion bulls spend much of their
time defending their territories and amassing their harems.
It is rare to find one posing for a family portrait. For a
brief moment, a newborn pup of this threatened species
was perfectly framed by its golden mother and dark
father, before the bull moved off to check out the rest
of his territory.

Hooker's sea lion (*Phocarctos hookeri*) family,
Enderby Island, Southern Ocean,
Antarctic realm, December

Camera: Nikon F4; Lens: 500mm
Film: Ektachrome 100 Plus

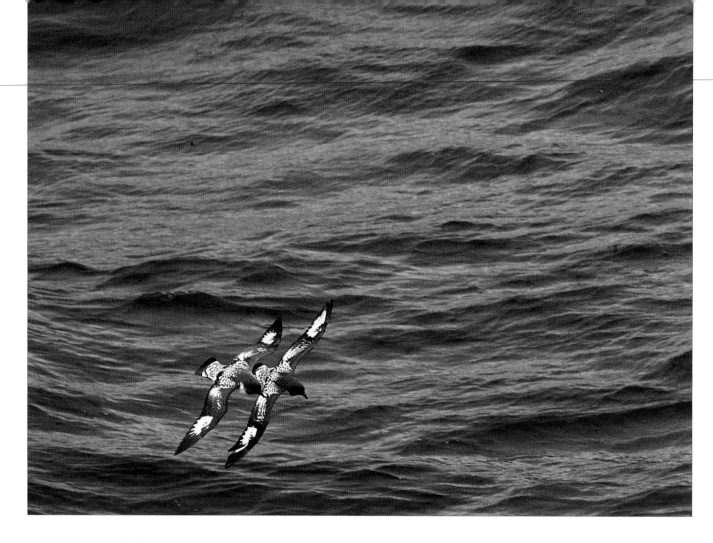

POETRY IN MOTION

Getting to the Antarctic continent involves many days at sea watching the interplay of sea and ice, as well as the itinerant seabirds that follow in a ship's wake. Among all the birds, my favorites were the graceful pintado petrels, which swooped so low as they flew alongside our ship that they appeared to almost kiss the ocean. Their monochrom-atic topsides provided a sharp contrast to the blue sea.

Pintado petrels (*Daption capense*),
Southern Ocean, Antarctic realm, November

Camera: Nikon F4; Lens: 400mm
Film: Kodachrome 200

SALMON SNATCH

In a remote part of Canada's west-coast rainforest, bears congregate in a salmon-spawning channel. Each bear develops a preferred technique for catching salmon. Some dive underwater, while others — like this one — keep their heads above water and use their paws to grab passing fish. The sidelight accentuates this bear's facial profile and sharp claws, while the green foliage adds color contrast.

Grizzly bear (*Ursus arctos*) with chum salmon,
Knight Inlet, British Columbia, Canada, October

Camera: Nikon F4; Lens: 500mm
Film: Ektachrome E100S

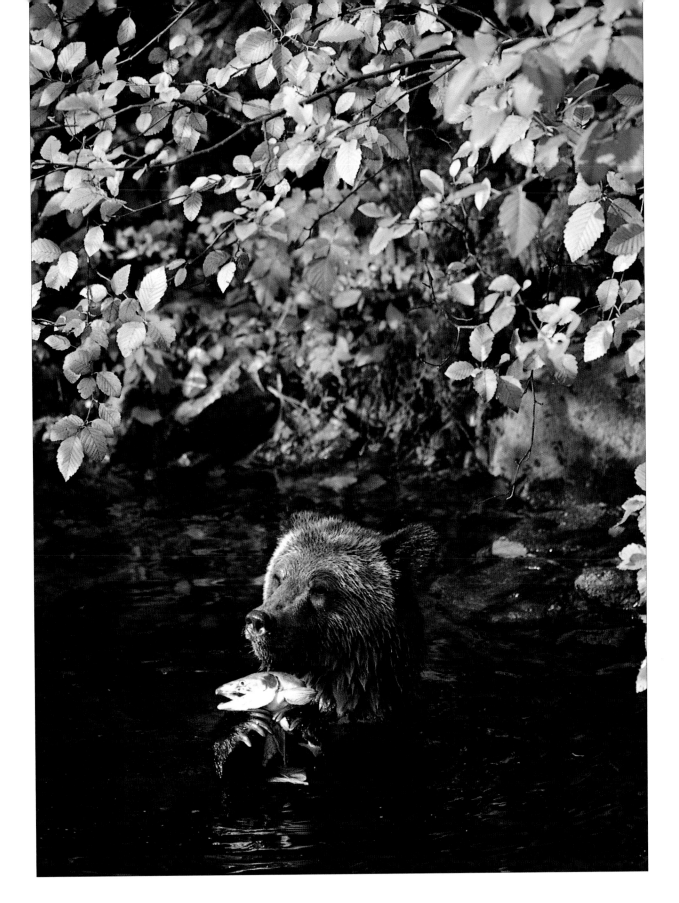

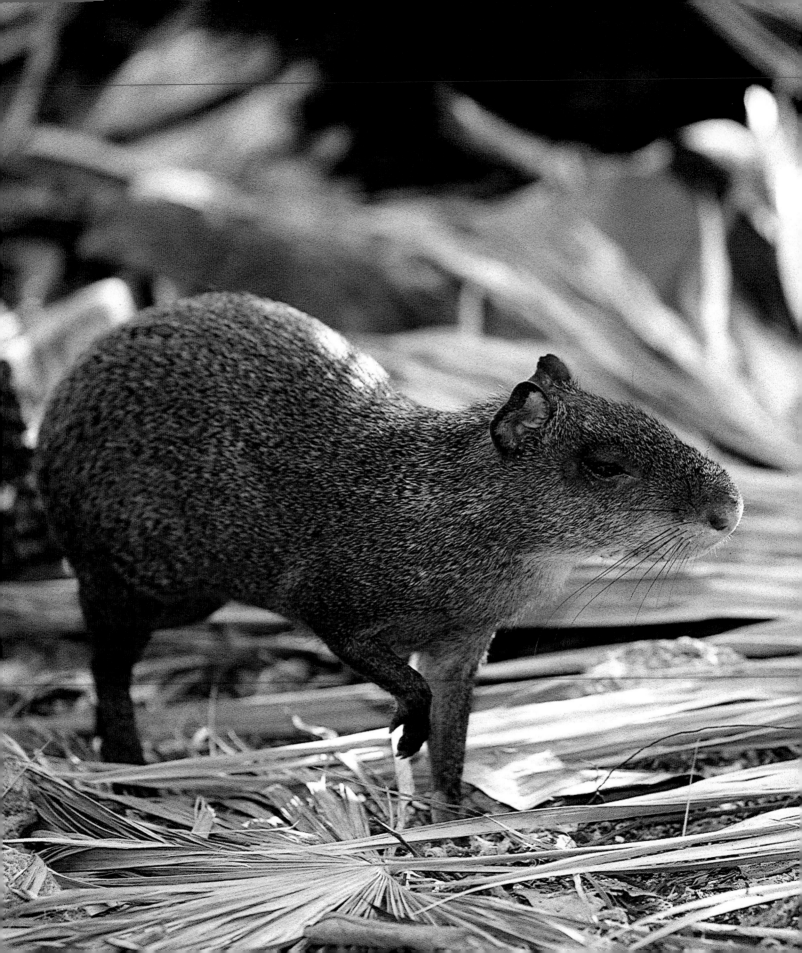

Natural World Portraits

PORTRAITS ARE ARGUABLY the most rewarding — and the most frustrating — type of wildlife photography. This genre embraces both complete animals as well as frame-filling heads and faces. When working in optimum lighting conditions with approachable and responsive animals, the rewards are great. All too often, however, in the early and late parts of the day the light is far from ideal. Furthermore, if the animal does not make for the nearest cover, it lies there motionless. It can, therefore, be very much a waiting game, and then suddenly the photo opportunities are all over within moments. Fast, long lenses not only aid photography in low light but can also help to capture a humorous antic or facial expression, which is such a bonus with an animal portrait.

CAUTIOUS STEP

Crouching low, I was rewarded late in the day by an agouti emerging out into the open. Sensing that the outsize rodent was being cautious, I waited a while to release the shutter. As the agouti froze with one leg raised off a carpet of dead palm leaves, I got my picture.

Agouti (*Dasyprocta* sp.), Roatán, Honduras, May

Camera: Nikon F4; Lens: 300mm; Film: Kodachrome 200

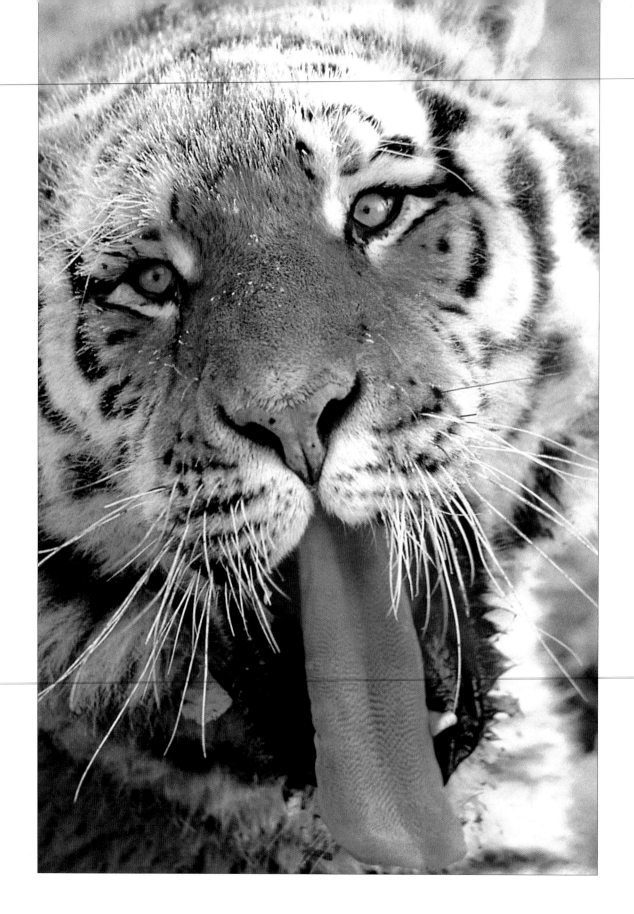

A DAWN YAWN

In winter, the Siberian tiger — the largest of all the big cats — has to withstand subzero temperatures at night. Their moist breath then freezes on their face fur. Like most cats, the tiger yawns repeatedly as it awakens. Warming rays from the sun have yet to reach the frosty head.

Siberian or amur tiger (*Panthera tigris altaica*) at breeding center, Harbin, China, January

Camera: Nikon F4S
Lens: 500mm
Film: Ektachrome 100S

FACE TO FACE

A head-on view of any African mammal with a low camera angle provides greater impact than a view angled down from a jeep. The unevenly lit face of this hunting dog, caused by crosslight late in the day, adds drama to an animal now known to hunt very efficiently in a pack.

Hunting dog or painted wolf (*Lycaon pictus*), Rhino Park, South Africa, October

Camera: Nikon F4
Lens: 300mm
Film: Ektachrome 100S

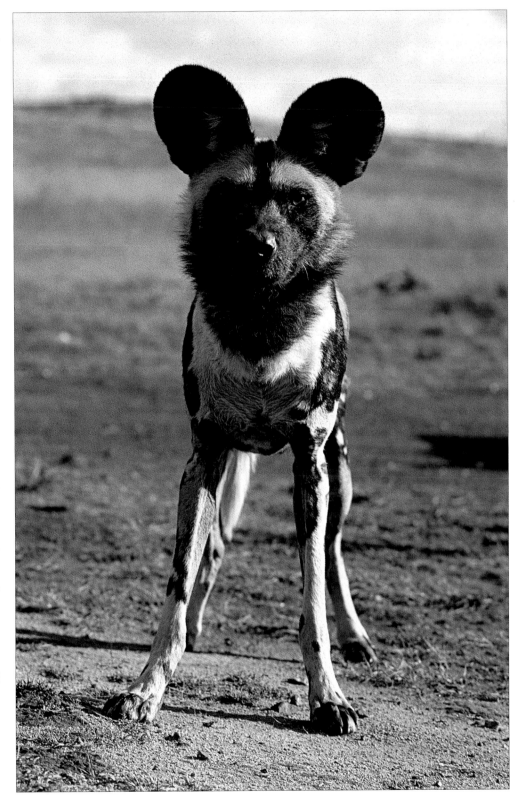

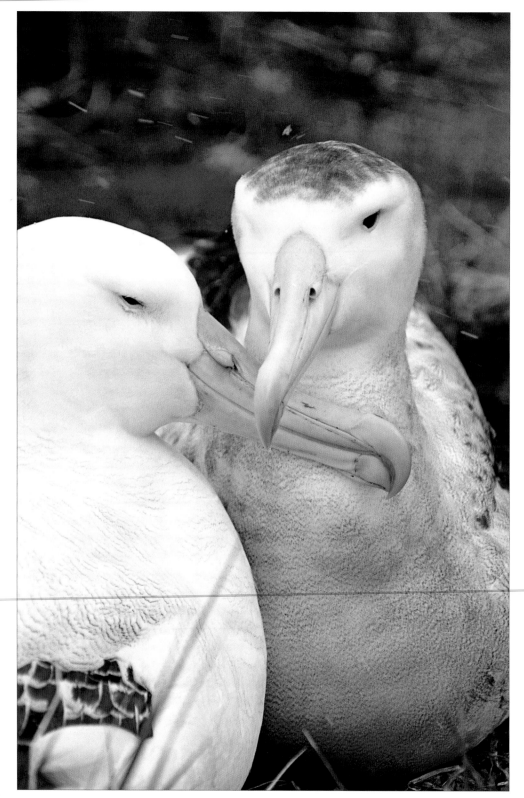

AMOROUS ALBATROSSES

My plans to take an albatross pair "gamming" at their nest site near South Georgia were thwarted as the sky darkened and the birds began to huddle together. When a snow flurry began to fall, I felt that my photo opportunities were fading fast, but as the pair turned toward each other with overlapping beaks, I chose a long lens to gain a tight crop of the devoted pair.

Pair of wandering albatross (*Diomedea exulans*), Prion Island, Southern Ocean, Antarctic realm, December

Camera: Nikon F4
Lens: 300mm
Film: Ektachrome 100S

BEE-EATER DUET

The branches of a dead tree fallen into the Zambezi River made a perfect perch for white-fronted bee-eaters. With the birds constantly coming and going, the composition was a fluid one. I began shooting horizontals with a 300mm lens. Then, using a 500mm lens, I composed a vertical format, with bare branches reminiscent of a Chinese ink-brush painting.

White-fronted bee-eaters (*Merops bullockoides*), Zambezi River, Zambia, September

Camera: Nikon F4S
Lens: 500mm
Film: Ektachrome E100S

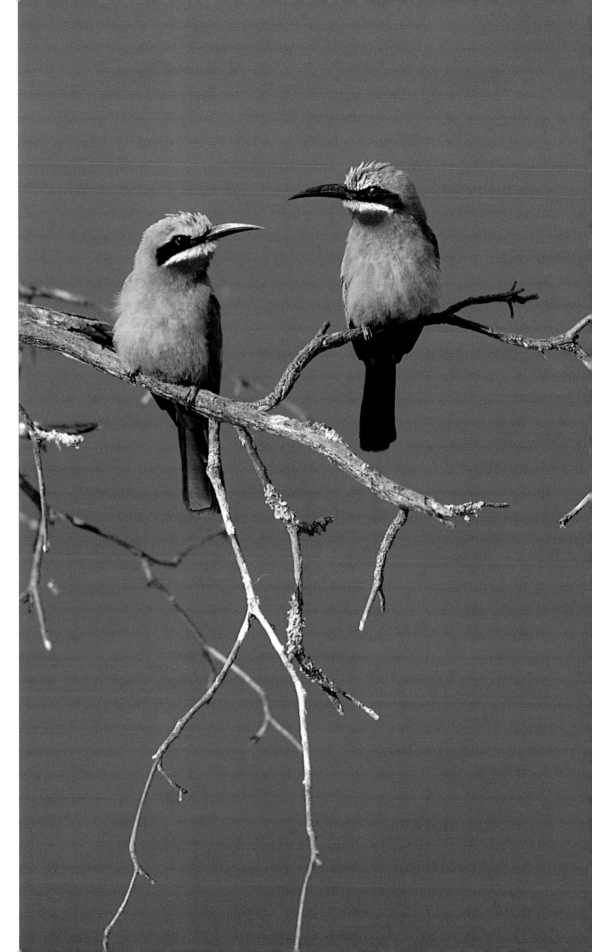

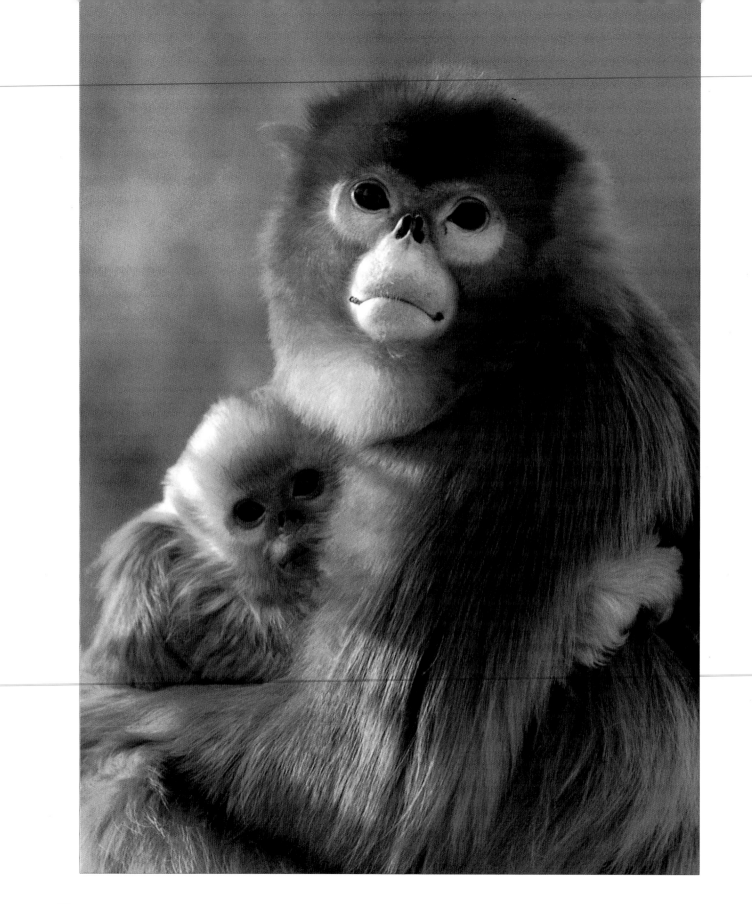

MOTHER LOVE

Golden snub-nosed monkeys share the same habitat as giant pandas, but also occur elsewhere in China. It is always a dilemma when a cute portrait, such as a mother cradling her youngster, is spoiled by out-of-focus plants. Do you take them and leave the distractions, or digitize them out? In this case, two stems in front of the mother's arm have been removed.

Golden snub-nosed monkeys (*Rhinopithecus roxellana*) in captive breeding center, near Beijing, China, January

Camera: Nikon F4
Lens: 500mm
Film: Ektachrome 200

EXPRESSIVE HOWLER

Pliable faces capable of evoking different moods ensure that mammalian portraits are less predictable than those of birds. Although it was captive, I still had to wait for more than two hours for this red howler to move into a small area spotlit by a shaft of sunlight, to gain a sparkle in the dark eyes. This expression depicts a relaxed animal, not an unhappy one.

Red howler (*Alouatta seniculus*), Twycross Zoo, Leicestershire, England, June

Camera: Nikon F4
Lens: 500mm
Film: Ektachrome 100S

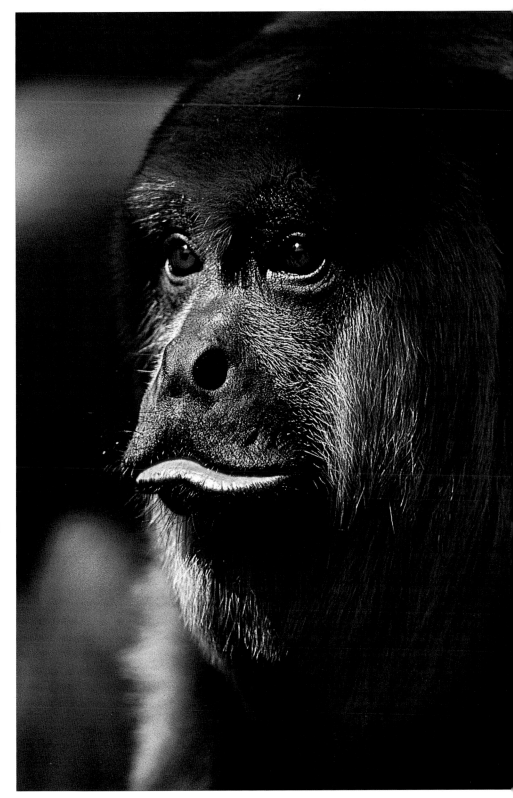

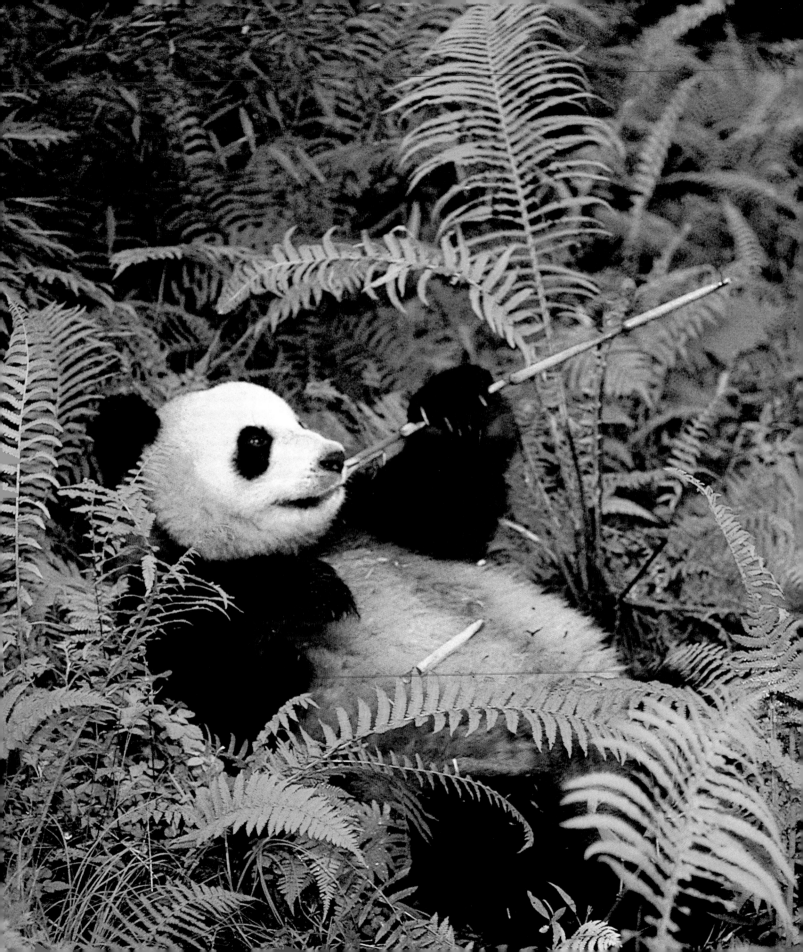

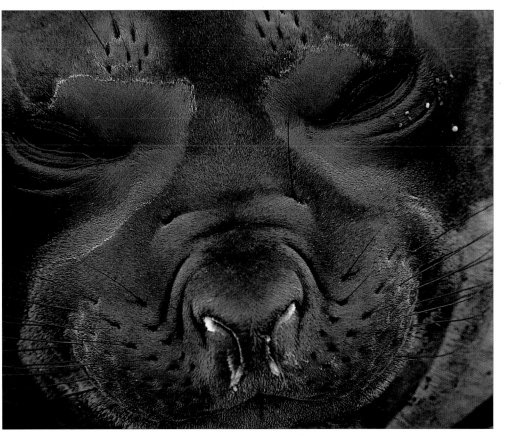

FEASTING AMONG FERNS

Reclining in a fern grove, a young giant panda feeds on a bamboo stem. The light beneath the evergreen trees was so poor that I had to push a 200-speed film to ISO 500 to freeze the movement of the panda's jaws, which were virtually in perpetual motion. A fill-flash added a sparkle to the dark eye within the black patch.

Giant panda (*Ailuropoda melanoleuca*) feeding on bamboo, Wolong Reserve, Sichuan Province, China, September

Camera: Nikon F4
Lens: 80–200 mm
Film: Kodachrome 200 pushed to ISO 500
Flash: Fill-flash

RELAXATION

This tight crop of a snoozing southern elephant seal was quite fortuitous. As I panned a long lens from one group of penguins to another, the seal appeared in the viewfinder. A moment later, the seal turned its head and the shot was gone. The nose is framed by the seal's curvaceous tear lines.

Southern elephant seal (*Mirounga leonina*), Macquarie Island, Southern Ocean, Antarctic realm, December

Camera: Nikon F4
Lens: 300mm
Film: Kodachrome 200

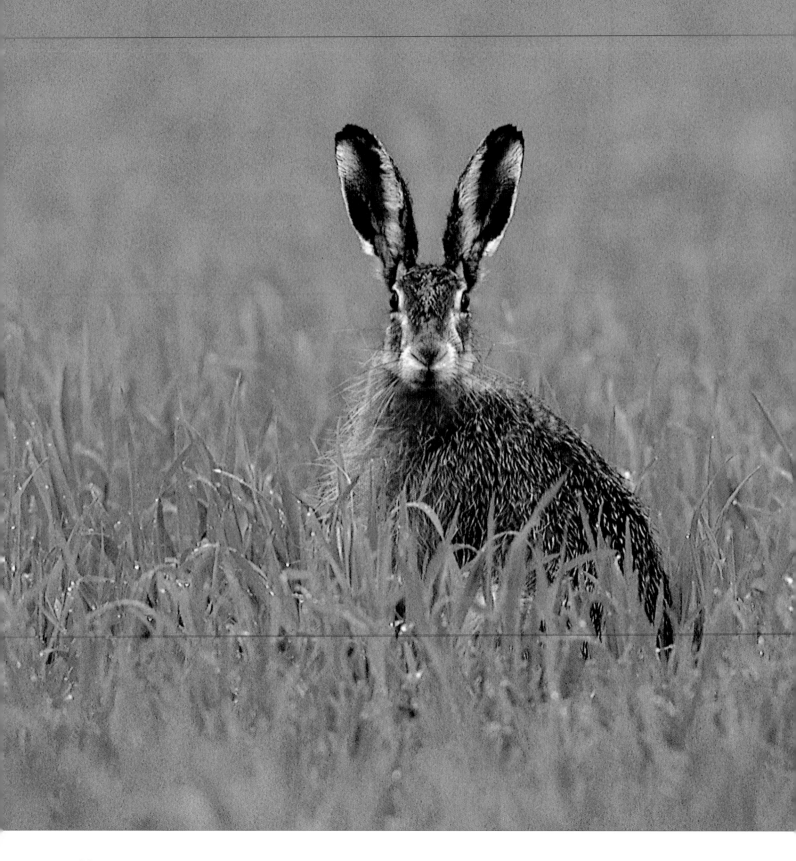

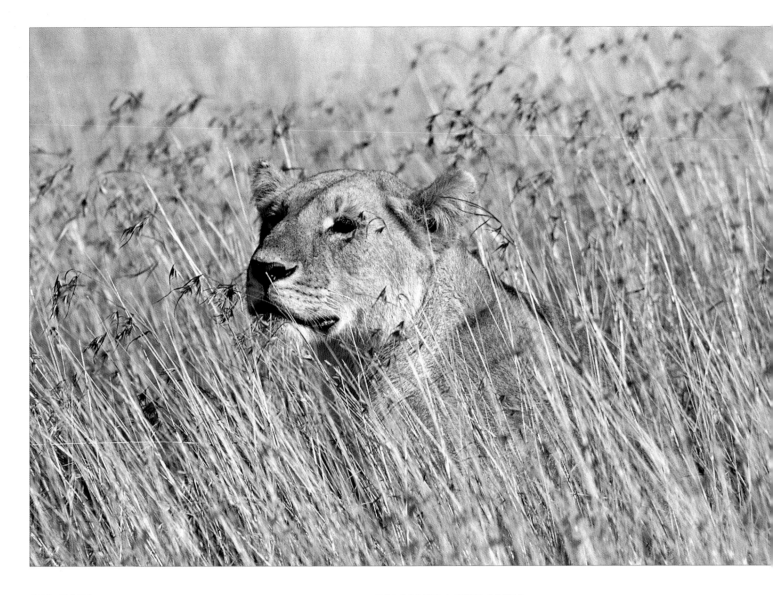

ALL EARS

Hares are wary at the best of times. Even by using a vehicle as a blind and fixing the camera to a window mount, I achieved only a few frames early each morning. The hare always reacted to the initial shutter release by waving its ears back and forth, then inching its body above the rye shoots. A quick burst of three or four frames was all I could achieve before the hare raced for cover.

Hare (*Lepus europaeus*) in rye field, Poland, May

Camera: Nikon F4; Lens: 500mm
Film: Fuji MS 100/1000 at ISO 640

CAMOUFLAGED LION

Lions — the largest of all Africa's big cats — are normally easy to spot, especially when walking on the lush green grass that sprouts after the rains, or when a pride flops down under a tree in the heat of the day. But seeding grass, yellowed with age, provides perfect cover for the golden cats. It hid this lioness so perfectly, I failed to notice she was there until she sat up to survey the scene.

Lioness (*Panthera leo*) in Masai Mara National Reserve, Kenya, August

Camera: Nikon F4; Lens: 200–400mm
Film: Ektachrome 100 Lumière

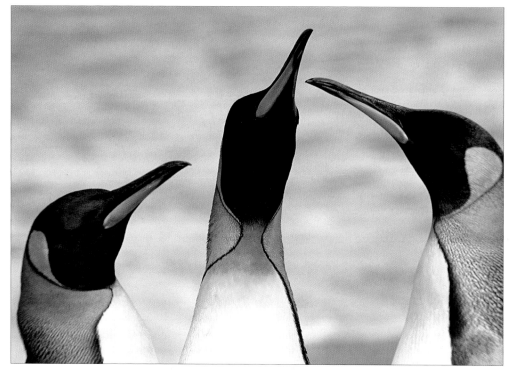

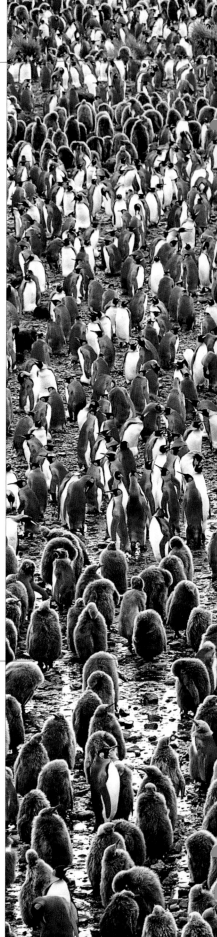

THREE KINGS

King penguins constantly move down from the rookery to feed in the sea. Three birds near the water's edge caught my eye and inspired a low-angled shot of "three kings," with the head of the central bird pointing skyward and the others turned in toward it. But with all the birds moving incessantly, I achieved only one shot out of a 36-exposure roll in which all the heads were separated and none of the bills overlapped.

King penguins (*Aptenodytes patagonica*), South Georgia, Southern Ocean, Antarctic realm, December

Camera: Nikon F4
Lens: 80–200mm
Film: Ektachrome 100S

PENGUIN MOSAIC

The vast size and huge density of a king penguin rookery makes it difficult to separate individual birds. To portray an impression of the density of the adults and brown chicks I climbed up onto a tussock-covered hill and looked down onto the melee below. I chose a medium format so that it could be used full frame, as here, or cropped to a vertical or a horizontal shape.

King penguin rookery (*Aptenodytes patagonica*), South Georgia, Southern Ocean, Antarctic realm, December

Camera: Hasselblad 500 C/M
Lens: 250mm
Film: Ektachrome 100S

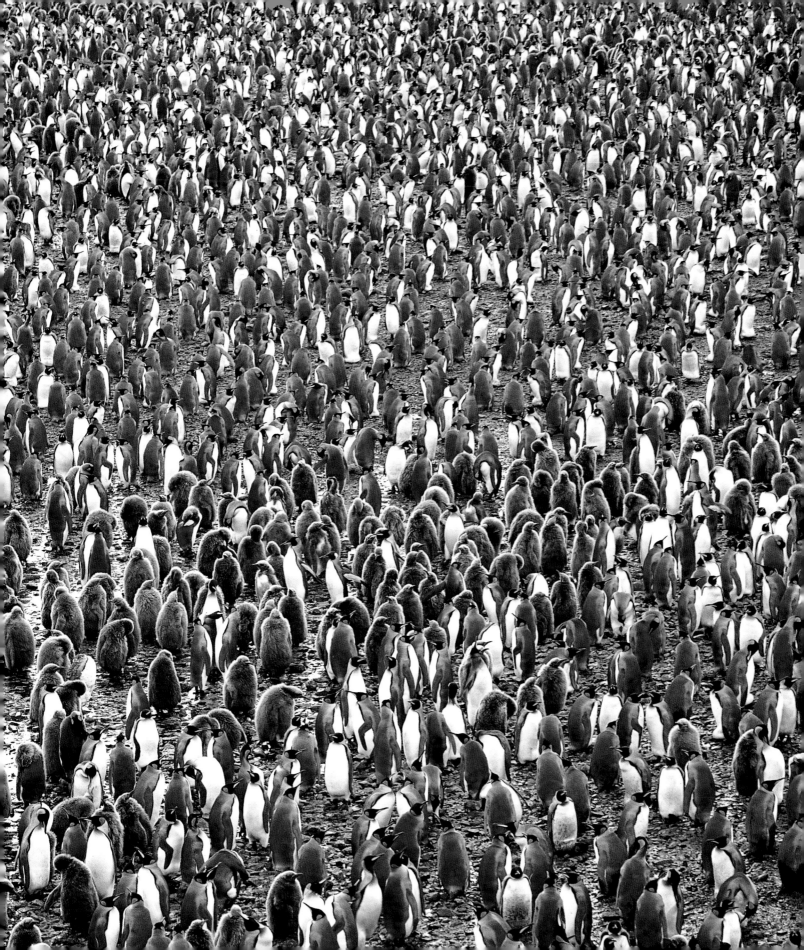

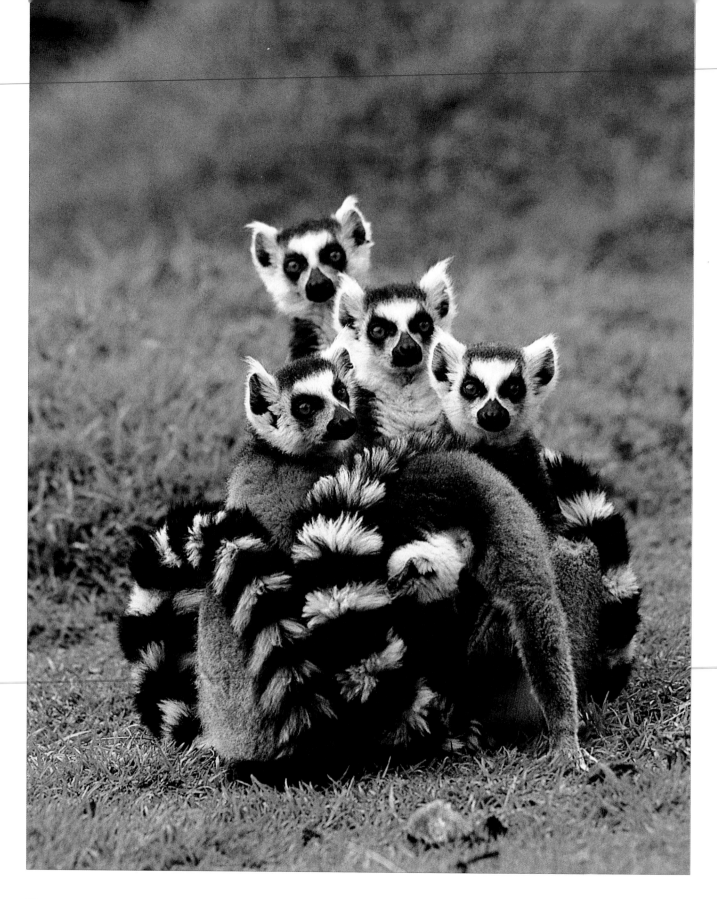

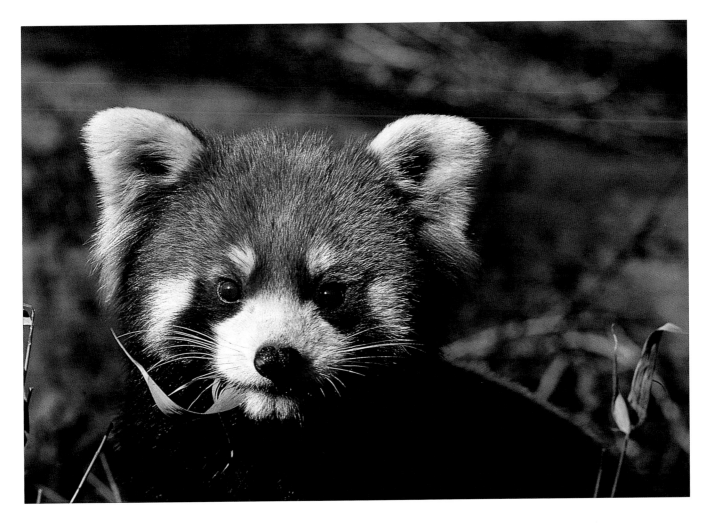

AMICABLE LEMURS

Ring-tailed lemurs are among the most photogenic of all Madagascar's lemurs, with their distinctive, triangular heads and monochromatic faces. Immediately attracted by the way this group huddled up to each other, I decided to wait until all the heads were looking at the camera. In the end, I had to settle for just three pairs of eyes focused on my lens before the lemurs dispersed.

Ring-tailed lemurs (*Lemur catta*), Parc Botanique et Zoologique, Antananarivo, Madagascar, October

Camera: Nikon F4; Lens: 500mm
Film: Kodachrome 200

FIREFOX

Red pandas share the same mountain forest as giant pandas in China's Wolong Reserve. Here, overnight temperatures plummet in winter and red pandas, known in China as firefoxes, wait until it warms up before they begin to feed. As this firefox looked up briefly while feeding on bamboo, its face became painted with a low-angled winter sun, and I had my portrait of an enchanting, endangered species.

Red panda (*Ailurus fulgens styani*) feeding within enclosure, Wolong Reserve, Sichuan Province, China, January

Camera: Nikon F4; Lens: 500mm
Film: Kodachrome 200

Capturing the Moment

DISTILLING THE OPTIMUM action into a single still frame is always a challenge. Being in the right place at the right time, and getting lucky, certainly helps of course. Because it is impractical to stand holding a long lens for any length of time, it helps to mount the camera on a tripod or monopod with a head that can be panned when the action starts. Time spent observing and anticipating animal behavior can be very productive if it leads to capturing a memorable moment. While waiting for an animal to move into a shot or react to a situation, it is a good idea to check that you have plenty of film in the camera, maybe deciding to push the film speed. It is always worth wasting a few frames and reloading with new film to ensure that you have plenty of frames for the action.

RED RIVER

During a run of dominant sockeye salmon, which occurs once every four years, the massed fish jostle for position on their upstream journey. The rippled surface and a slow shutter speed helped to convey an impression of movement of scarlet bodies.

Dominant run of sockeye salmon (*Oncorhynchus nerka*), Adams River, British Columbia, Canada, October

Camera: Nikon F4; Lens: 300mm; Film: Ektachrome 100S

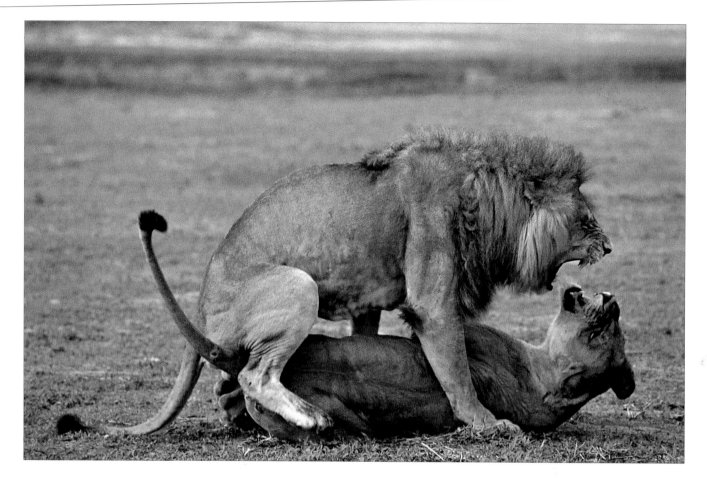

ENRAPTURED

Lions will mate repeatedly throughout a period of several days, so when a pair are in an open area, getting pictures of the coupling is not difficult. However, in all the times I have photographed mating lions, never before had I captured this particular stance, just as the female twists her head and snarls directly into her mate's face. A fast motor drive was essential for this shot.

Lions (*Panthera leo*) mating, Moremi Game Reserve, Okavango Delta, Botswana, November

Camera: Nikon F4; Lens: 300mm; Film: Ektachrome 100S

GREETING CEREMONY

It helps to have a knowledgeable guide who can alert you to interesting behavior. Here, as a low-ranking elephant approaches a more dominant individual, it inserts the tip of its trunk inside the mouth of the other animal, who stands quite passively. It is possible that this behavior arises from a habit developed when young, for a calf will insert its trunk into its mother's mouth for comfort.

African elephant (*Loxodonta africana*) greeting another, Moremi Game Reserve, Okavango Delta, Botswana, February

Camera: Nikon F5; Lens: 500mm; Film: Ektachrome 100S

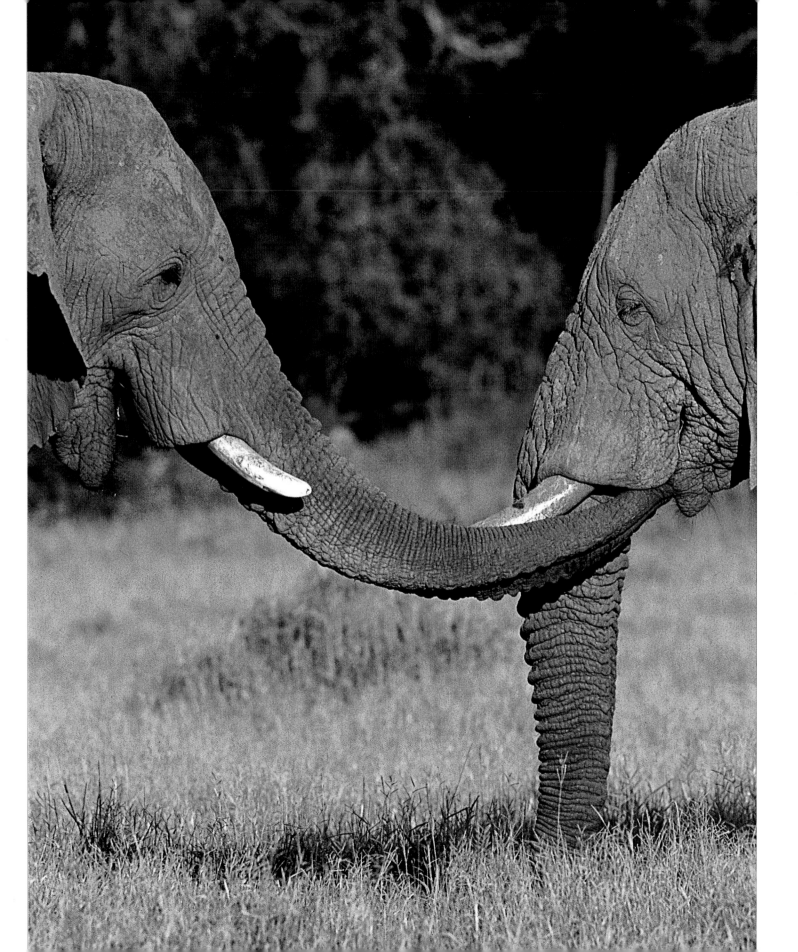

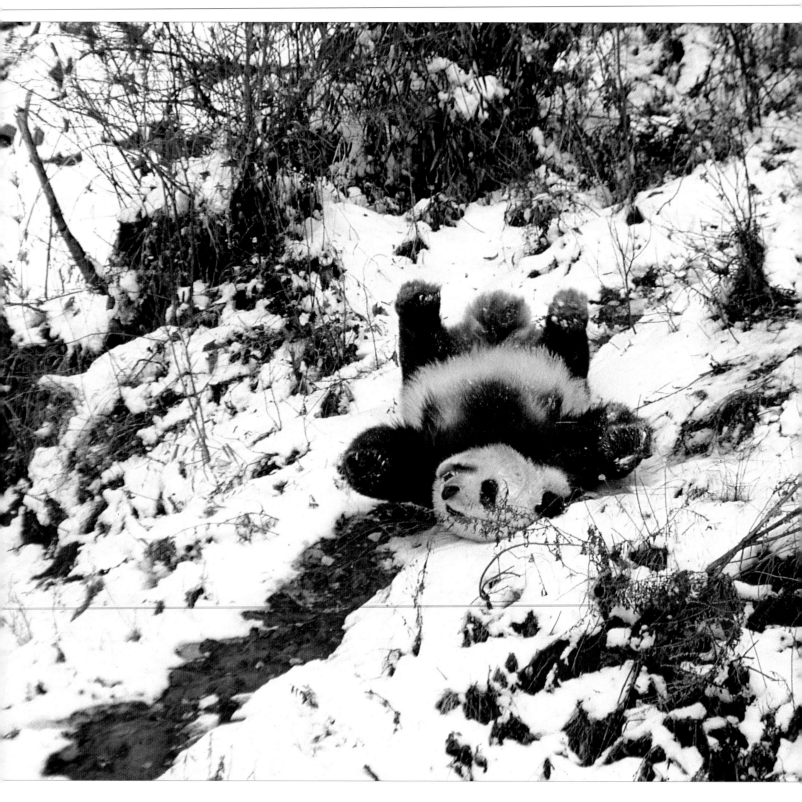

SLIPPERY SLOPE

A giant panda can spend up to eighteen of every twenty-four hours feeding, so, after sleeping, this leaves little time for other activities. Pandas do not hibernate, so I paid a visit to China in the hope of shooting them in snow. When this panda lost its footing and slithered ignominiously down the snow-covered slope, I had an unexpected, humorous picture. Contrasty, monochromatic pandas are best lit by soft, diffused light, as here.

Giant panda (*Ailuropoda melanoleuca*), Wolong Reserve, Sichuan Province, China, January

Camera: Nikon F4; Lens: 80–200mm
Film: Ektachrome 100 Plus

FLEXING FLIPPERS

Just as I lay prone on the ice to get a penguin chick's-eye view of the adult birds, a youngster obligingly flexed its flippers. Not until I focused the camera did I realize that, unlike the panda, the emperor penguin chick has a white eye patch. Metering can be a problem when working in a white wilderness, but quite fortuitously, the gray down of the emperor penguin chick makes an excellent eighteen percent gray card!

Emperor penguin chick (*Aptenodytes forsteri*), Atka Bay, Southern Ocean, Antarctic realm, November

Camera: Nikon F3 with cold-weather battery pack; Lens: 500mm
Film: Kodachrome 200

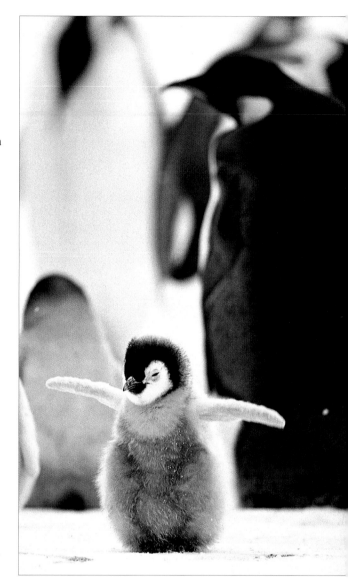

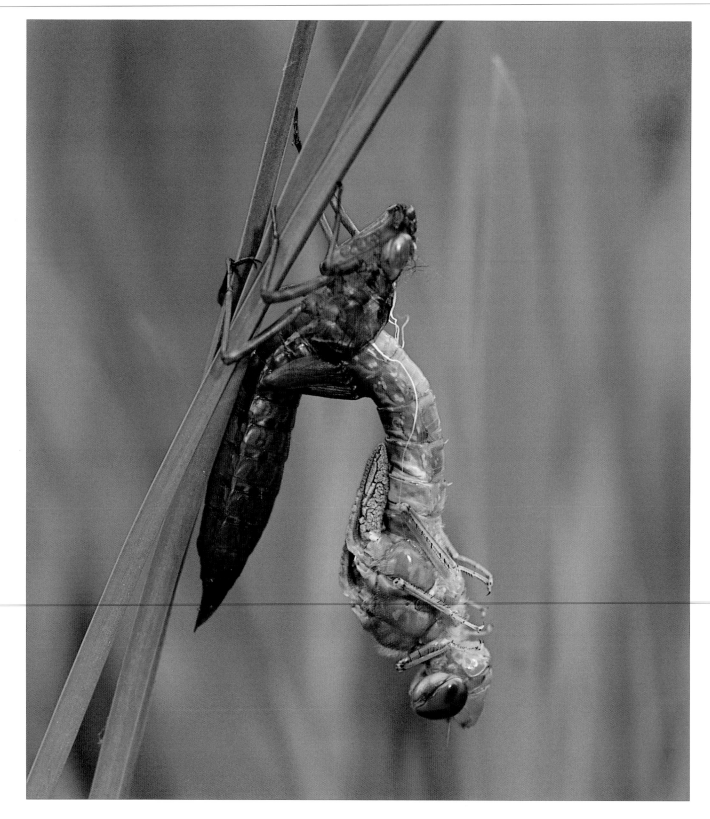

METAMORPHOSIS

The transformation from a drab-colored aquatic nymph to a beautiful dragonfly is surely one of nature's miracles. A dragonfly often emerges from its shuck at dawn, but this one appeared at dusk. I waited until the crumpled wings were visible. Checking the depth of field, I used an aperture that brought the shuck and the dragonfly all into focus, yet blurred the background. A fill-flash helped to add a little sparkle.

Southern aeshna dragonfly (*Aeshna cyanea*) emerging from shuck, Surrey, England, June

Camera: Nikon F4
Lens: 105mm Micro-Nikkor
Film: Ektachrome 100 Lumière
Flash: Fill-flash

POLLINATION

Male flowers of conifers produce copious microscopic pollen grains that, when released as a mass, form a distinct yellow cloud. If the time of release coincides with a sudden gust of wind moving the branches, the pollen clouds are clearly visible. Even when using a fast shutter speed, the motion of the pollen cloud appears soft-edged. Much of the pollen liberated by wind ends up forming a custard-like layer on puddles.

Ponderosa pine (*Pinus ponderosa*) releasing pollen, near Darby, Montana, USA, June

Camera: Nikon F4; Lens: 80–200mm
Film: Kodachrome 200

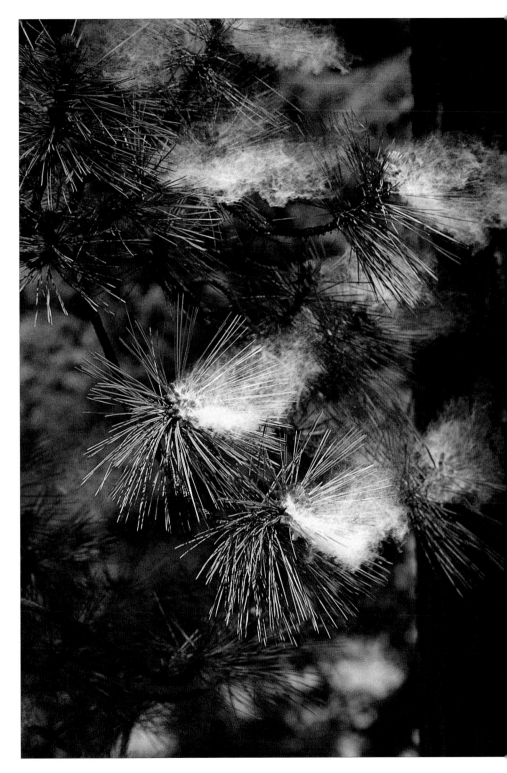

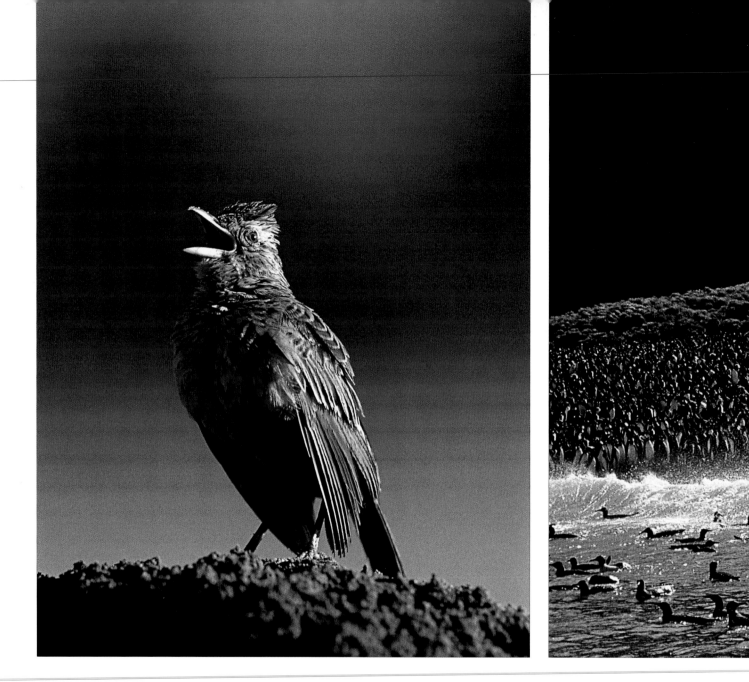

DAWN SERENADE

Atop a termite mound a small lark towers above tall grasses, gaining an all-around vantage point. The pre-serenade behavior of this particular lark is a photographer's dream, because moments before it calls, the bird flaps its wings. I was unhappy with my camera angle, and at the risk of losing the shot, we repositioned the jeep so that the bird was painted with the dawn light, but the lark was so intent on its dawn ritual that it barely blinked.

Rufous-naped lark (*Mirafa africana*), Moremi Game Reserve,
Okavango Delta, Botswana, February

Camera: Nikon F5; Lens: 500mm; Film: Ektachrome 100S

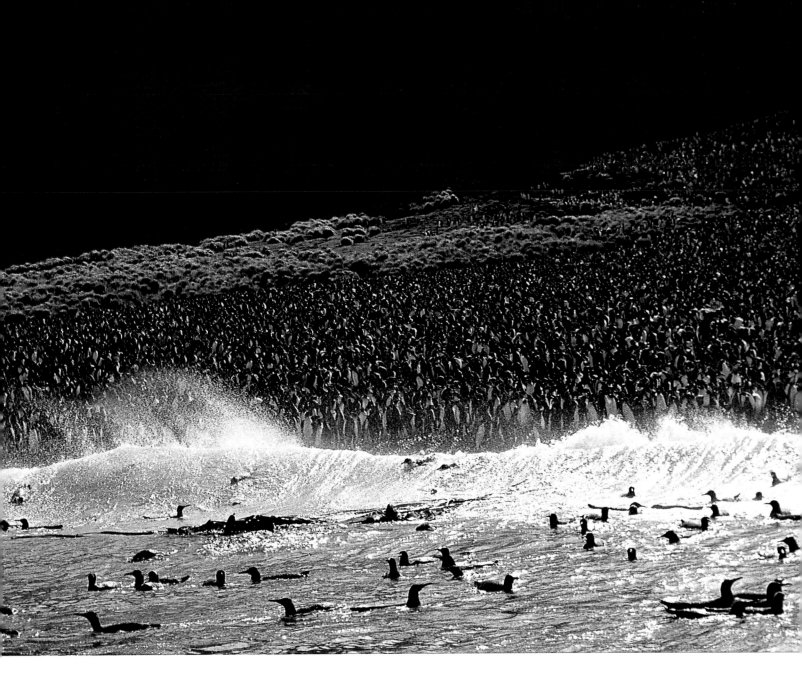

RAFTING THE SURF

We had heard that the king penguins from Macquarie Island would paddle out to greet us, and sure enough, no sooner were we in our inflatable boat than a flotilla converged toward us. Almost on cue, the clouds parted and the sun beamed behind a wave breaking on a beach crammed with jostling penguins, standing flipper to flipper. With a low camera angle and zoom lens I was able to seize a magical, unforgettable moment.

King penguins (*Aptenodytes patagonica*) in surf, Lusitania Bay, Macquarie Island, Southern Ocean, Antarctic realm, December

Camera: Nikon F4; Lens: 80–200mm; Film: Ektachrome 100 Plus

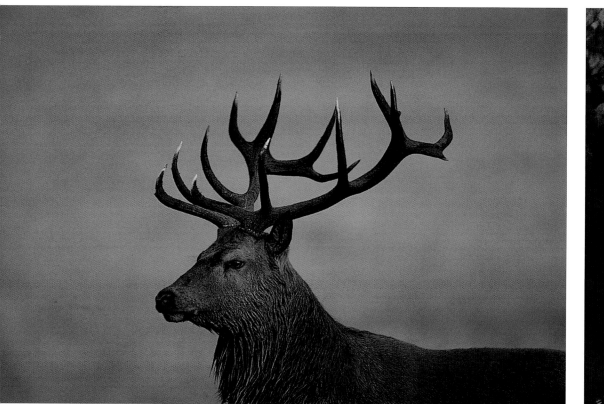

BREAKING DAWN

I visited a deer park in the hope of getting some action at first light. In the end, the picture I liked best does not depict any action, but captures instead a fleeting moment, when dead bracken was bathed in a glorious dawn light seconds before the deer became lit. The use of a fast, long lens was an essential factor in achieving a shallow depth of field that separated the stag from the glowing bracken backdrop.

Red deer stag (*Cervus elaphus*), Bradgate Deer Park, Leicestershire, England, October

Camera: Nikon F4
Lens: 500mm
Film: Kodachrome 200

DICING WITH DEATH

When salmon are running upriver in brown bear territory, it is not too difficult to get pictures of bears gorging on the seasonal bounty. Working from a pylon blind in British Columbia, the picture that excited me most was a single frame of a salmon evading the paws and jaws of a mother and her cub. The light was so low beneath coniferous trees overhanging the river that I had to push my film to ISO 800.

Grizzly bears (*Ursus arctos*) with salmon, Knight Inlet, British Columbia, Canada, September

Camera: Nikon F4; Lens: 500mm
Film: Fuji MS 100/1000 rated at ISO 800

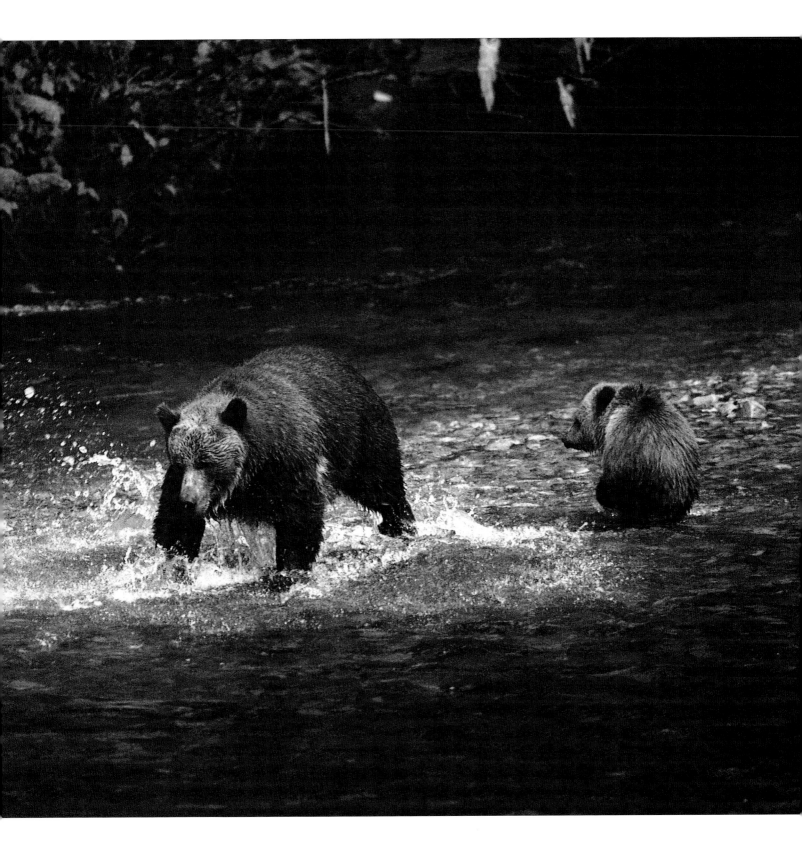

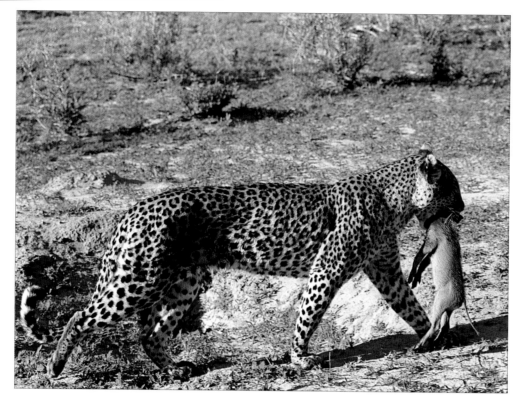

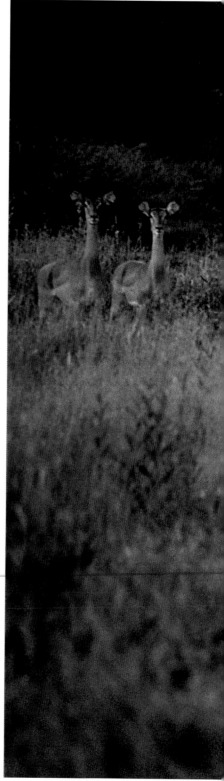

OPPORTUNISTIC MOMENT

Leopards typically hunt at night, but a hungry individual is never slow to capitalize on an easy meal. The sun was already high when we spotted this leopard on our way back to camp. Seconds after a female warthog emerged from her burrow, the leopard dove down the hole and surfaced with a young warthog. Gaining such an easy meal was an opportunistic moment, as were the odds of witnessing the speedy demise.

Leopard (*Panthera pardus*) with baby warthog (*Pachochoerus aethiopicus*), Moremi Game Reserve, Okavango Delta, Botswana, November

Camera: Nikon F4; Lens: 300mm
Film: Ektachrome 100S

ALERT PREY

The light was fading fast when we came across a line of impala with their eyes and ears focused toward our jeep. I was attracted by the pattern of their outstretched ears, and as I focused on them a leopard moved into the bottom of the frame. This shot encapsulates the typical reaction of prey to a known predator who, that night, happened to be intent on hunting elsewhere.

Impala (*Aepyceros melampus*) herd watching a leopard (*Panthera pardus*), Moremi Game Reserve, Okavango Delta, Botswana, February

Camera: Nikon F4; Lens: 300mm
Film: Ektachrome 100S

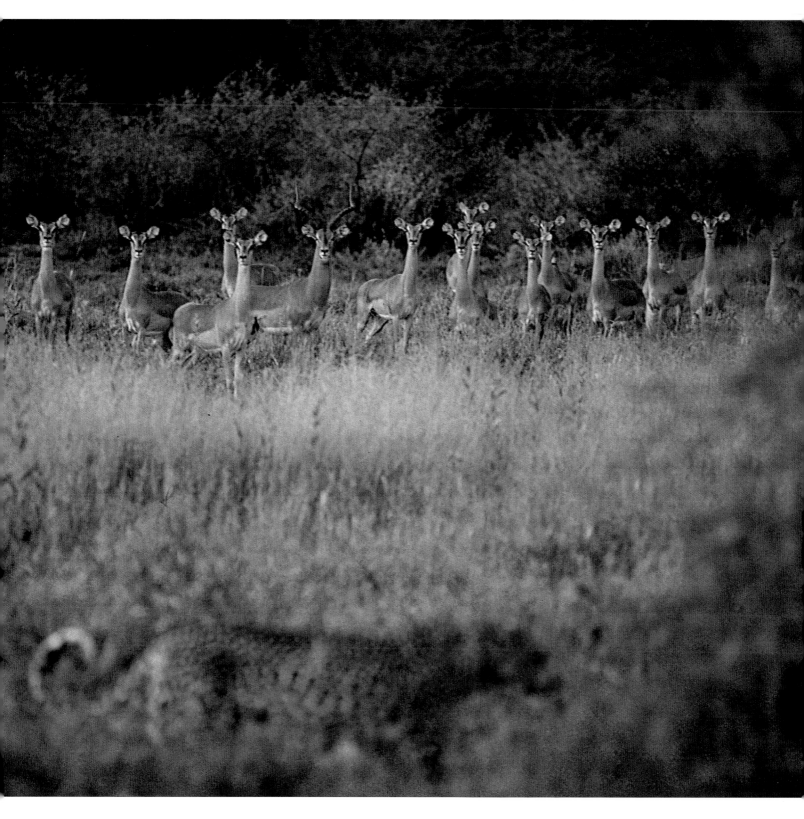

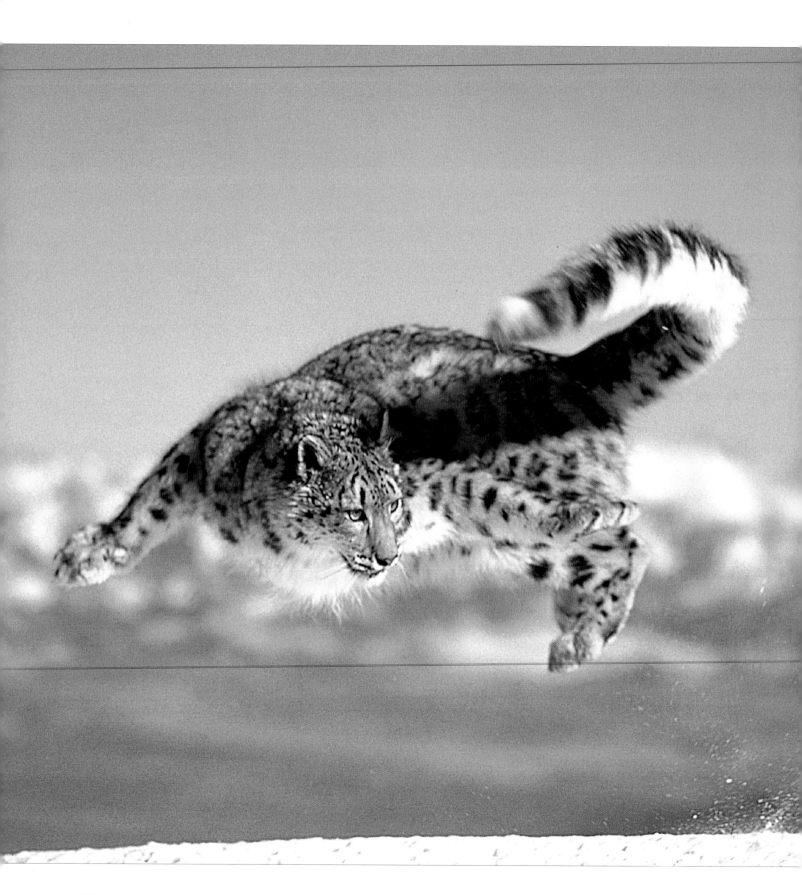

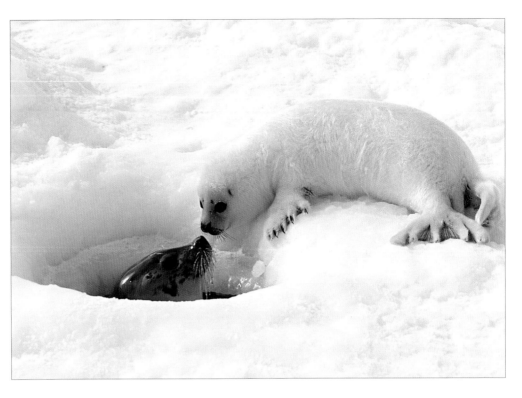

LEOPARD'S LEAP

On a glorious, sunny, midwinter's day
I shared a short helicopter ride with a
captive-bred leopard to a pristine, snow-
covered ridge. Within moments of walking
out onto the snow, I began to unpack my
gear. When I sensed a movement out
of the corner of my eye, I turned and
instinctively dropped onto my knees
to gain a low angle just as the cat leaped
into the air.

Snow leopard (*Panthera uncia*),
Montana, USA, February

Camera: Hasselblad 501CM
Lens: 250mm
Film: Ektachrome 100 Plus

TOUCHING MOMENT

Initially, harp seal pups spend their days
feeding and lying on the ice, but gradually
they become more adventurous. When I
spotted a pup moving toward a hole in
the ice, I waited for the moment when the
mother surfaced to give her pup a kiss
of recognition. Subzero temperatures
adversely affect batteries, so I made a
wooly coat to insulate my camera.

Mother harp seal (*Phoca groenlandica*)
greets pup, Gulf of Saint Lawrence,
Quebec, Canada, March

Camera: Nikon F4
Lens: 300mm
Film: Ektachrome 100 Plus

Visualizing the Image

PORTRAYING THE NATURAL world in a creative way is an exciting extension of the representative approach to wildlife photography. Creative interpretations have to be thought through, however — they don't happen by accident. If images are to be made in the camera, they have to be first visualized in the mind's eye, before the shutter is released. If, however, they are modified at a later date, the non-digital, post-camera processes available include cross-processing, image transfer, and image lift-off. Once a print or transparency is scanned into a computer, the creative options for modifying a digital image are limitless. No longer do you have to restrict your work to a narrow time slot when a flower is blooming, or animals are breeding — digital imagery is as expansive as the mind itself.

PULSATING PATTERNS

While I was reloading film after photographing flamingos filter-feeding, the lens tilted forward. Just before I corrected the angle, I glanced through the viewfinder and saw this accidental framing of pink necks constantly pulsating in the rippled water.

Greater flamingos (*Phoenicopterus ruber*) reflected in water, Wildfowl and Wetlands Trust, Slimbridge, Gloucestershire, England, March

Camera: Nikon F4; Lens 500mm; Film: Ektachrome 200

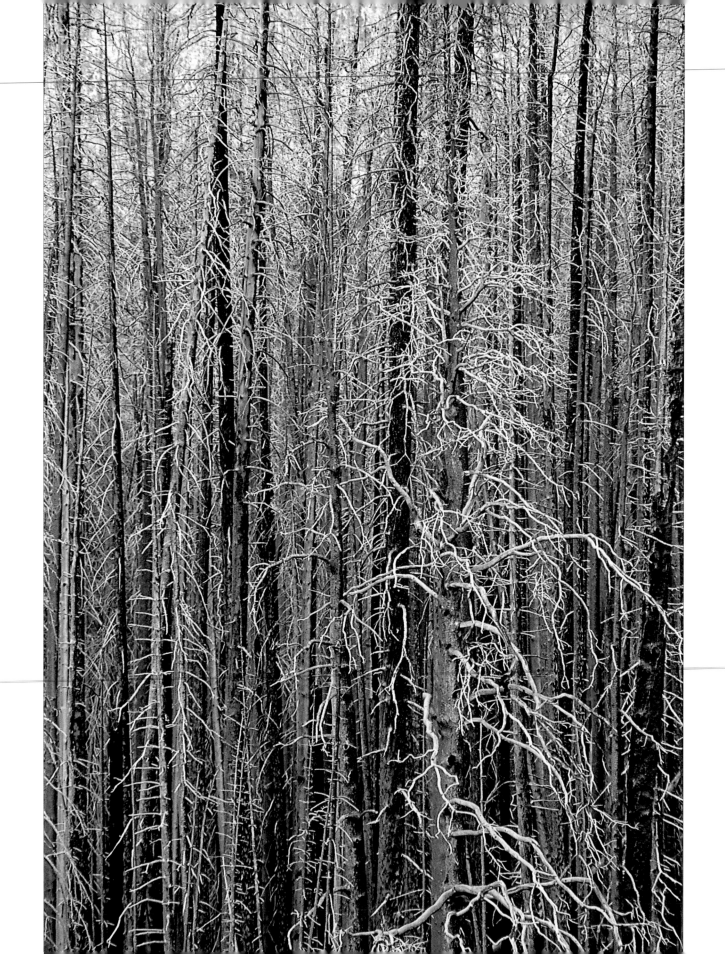

OUT OF THE FLAMES

Charred stands of trees burned in the 1988 Yellowstone fires contrast well against winter snow, but during summer I tend to avoid the burned patches. On Mount Washburn, however, the contrast between the irregular, white branches and the charred trunks of the skeletal pines was especially graphic when selected with a long telephoto lens.

Burned lodgepole pines (*Pinus contorta*),
Yellowstone National Park, Wyoming, USA, June

Camera: Nikon F4; Lens: 500mm
Film: Ektachrome 100 Plus

PETAL POWER

It is surprising how the concept of a most familiar flower has to be revised when it is viewed larger than life-size with minimal focus. Working on an overcast day to utilize soft, diffuse light and shooting at maximum aperture, I gained an abstract interpretation of the heart of a carnation flower.

Detail of carnation (*Dianthus* sp.), Surrey, England, June

Camera: Nikon F4
Lens: 105mm Micro-Nikkor with X4 close-up lens
Film: Ektachrome 100 Lumière

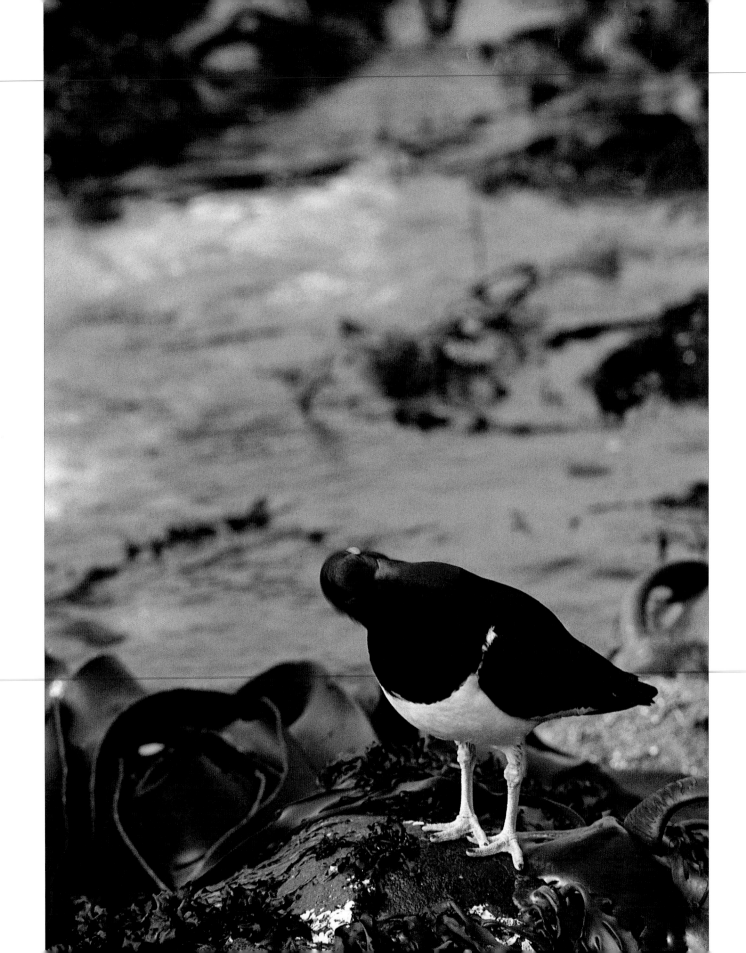

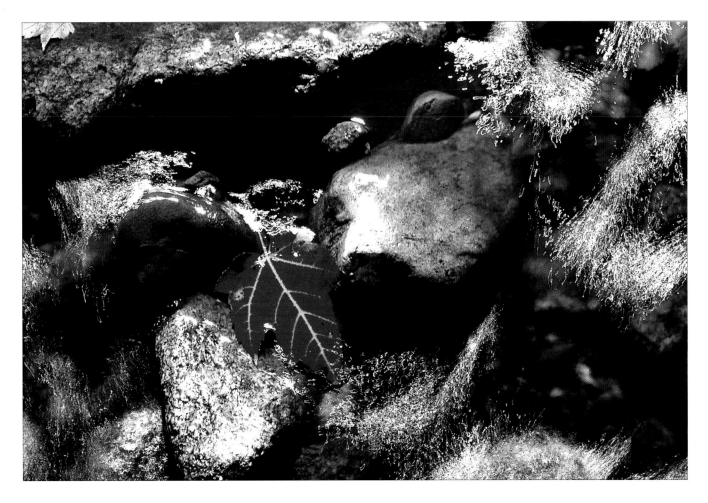

PREENING MOTION

The Falkland Islands are a bird photographer's paradise. It was here that I found an oystercatcher preening on seaweed-covered rocks in the intertidal zone. Instead of using a fast shutter speed to freeze all movement, I decided to use a ⅓₀-second exposure to blur the red bill and convey the repetitive preening action of the attractive wader.

Magellanic oystercatcher (*Haematopus leucopodus*) preening, Sea Lion Island, Falkland Islands, November

Camera: Nikon F4; Lens: 300mm
Film: Kodachrome 200

ROCK CAPTURE

A red maple leaf trapped in swirling water between two rocks caught my eye. To get this close-up I waded out into midstream with my camera and tripod. Bright sunspots dancing on the water gave me the idea of using a one-second exposure to record them as bright, irregular traces, in contrast to the static, colorful leaf.

Red maple (*Acer rubrum*) leaf in river, Acadia National Park, Maine, USA, October

Camera: Nikon F3; Lens: 55mm Micro-Nikkor
Film: Kodachrome 64

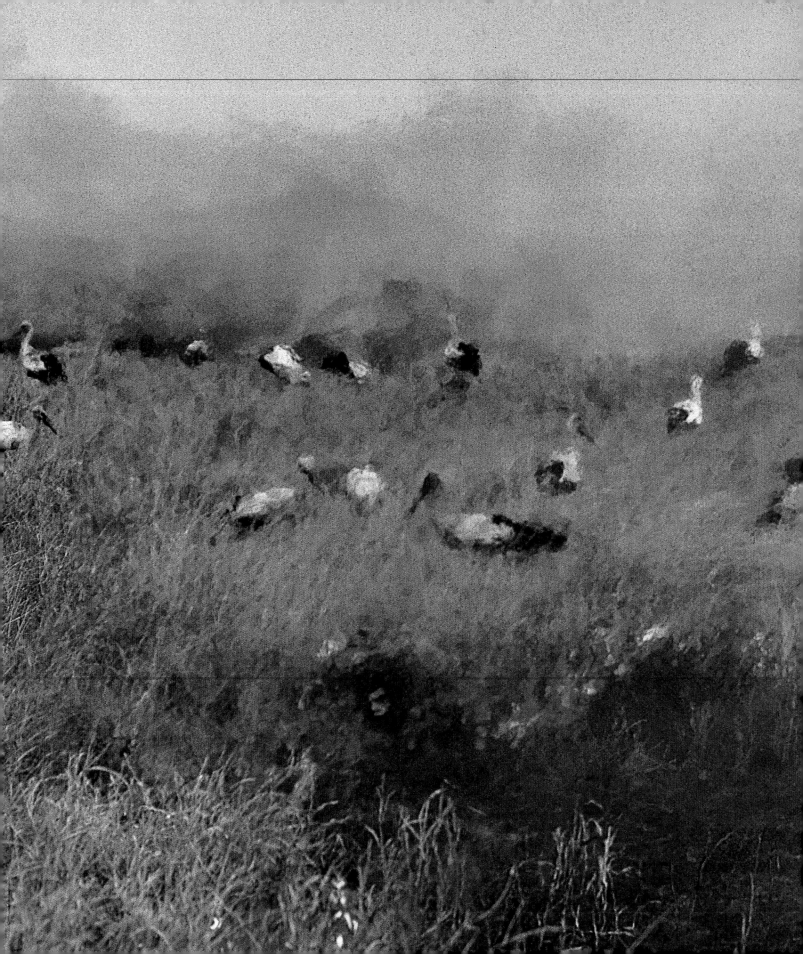

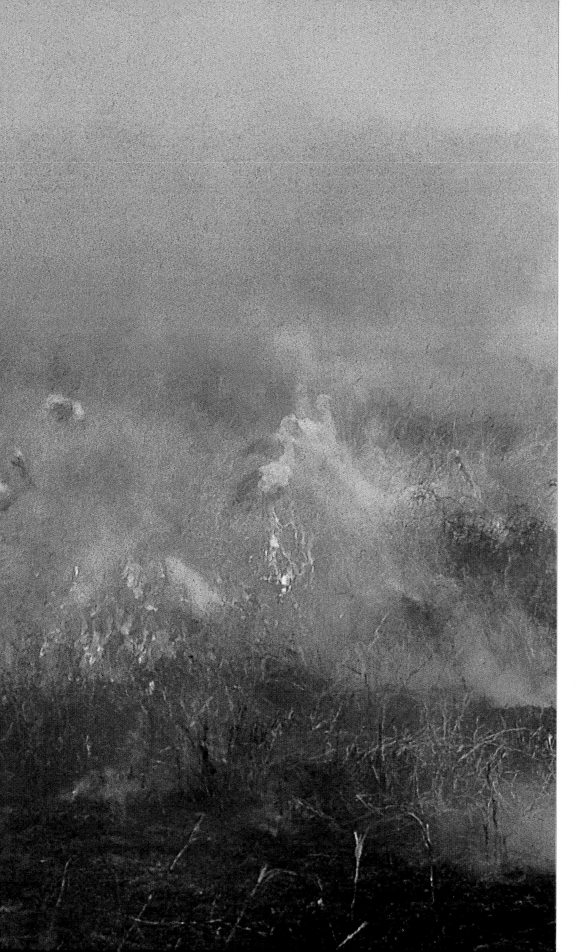

FIERY ABSTRACT

There are times when an initial misfortune turns into a positive advantage for a rare photo opportunity. Persistent smoke clouds, produced by daily burns of African grassland, made landscape photography impossible, forcing me to head out in the opposite direction. Driving over the brow of a hill one day, I saw the fire-line nearing the track below, with black-and-white objects moving in close proximity to the fire. They were white storks, feeding avidly on locusts and grasshoppers flying from the flames. I urged my driver to stop before the fire so I could utilize the heat haze to record the intriguing behavior as an Impressionistic scene.

White storks (*Ciconia ciconia*) feeding in front of grassland fire, Masai Mara National Reserve, Kenya, July

Camera: Nikon F4
Lens: 200mm
Film: Kodachrome 200

IMPRESSIONIST LUPINS

Fate played a major part in my getting
this austral summer picture. In an
attempt to salvage something from a
fruitless drive to the west coast of New
Zealand's South Island, where a trek for
the rare Fjordland-crested penguin had
been cancelled, I set off for the Mount
Cook area. Here, swards of multicolored
lupins enliven the roadsides in summer. I
was in luck. The flowers were perfect.
After some conventional shots, I decided
to create an Impressionistic image by
shooting multiple exposures on a single
frame. Unsure at what speed to re-rate
the film, I opted for ISO 1600, although
in later shots I simply multiplied the film
speed by the number of exposures. By
slightly adjusting the framing (but not
the focus) each time, the blocks of color
were softened so that they merged
together. The resulting image did not
exist in reality but was painstakingly built
up, exposure upon exposure, similar to
the way paint is applied on canvas. Who
says a camera never lies?

Roadside lupins (*Lupinus* sp.) near Lake
Tekapo, New Zealand, December

Camera: Nikon F4; Lens: 80–200mm
Film: Ektachrome 100 Lumière rated
at ISO 1600 and exposed thirty times
on one frame

PALM PRINTS

A simple study of arching, sunlit palm fronds was chosen for a multiexposure impression. Up-rating the film to ISO 3200, I made thirty separate exposures (see page 116) — each time making very small adjustments to the composition — on one frame. The result was an image of palm fronds apparently blowing in the wind.

Palm fronds, Huntington Botanic Garden, California, USA, April

Camera: Nikon F4; Lens: 80–200mm
Film: Ektachrome 100 Lumière rated at ISO 3200 and exposed thirty times on one frame

SHIMMERING ASPENS

The perpetual motion of golden aspen leaves blowing in the wind against a blue sky is one of nature's glorious fall spectacles. The shimmering foliage gave me the idea of using a variation of the multiexposure technique. Once again, the film was up-rated, but the camera was fixed because the leaves were constantly moving.

Quaking aspen leaves (*Populus tremuloides*), Twin Lakes, Colorado, USA, September

Camera: Nikon F4; Lens: 80–200mm
Film: Ektachrome 100S rated at ISO 1600, and exposed sixteen times on one frame

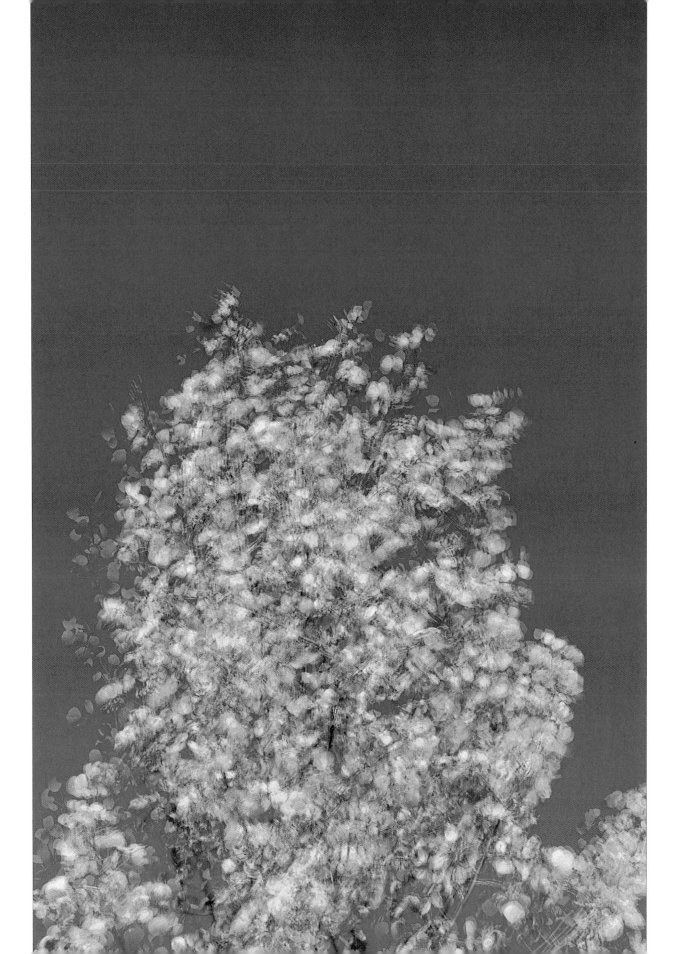

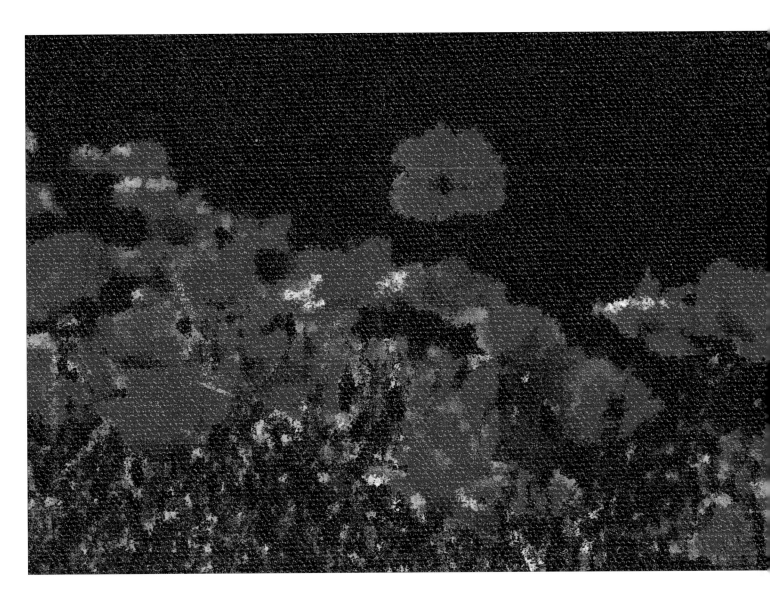

SUNFLOWER IMPRESSIONS

After viewing the "Monet in the 20th Century" exhibition at London's Royal Academy, I became inspired to create digitized art images from my existing floral pictures. Selecting parts of a frame with bold colors and no white areas, I used Adobe Photoshop to simulate bold brush-strokes of sunflowers bathed by a dawn sun against a blue sky, originally taken using a low camera angle.

Nodding sunflowers (*Helianthella quinquenervis*) taken at Crested Butte, Colorado, USA, July, digitally modified using Adobe Photoshop

PAINTERLY POPPIES

Using a shot of poppies dramatically lit against a black background, I used Adobe Photoshop again to portray an Impressionistic style. This time the print was made on canvas inkjet paper. Digital manipulation extends the scope for interpreting a subject in new ways, at any time of year — irrespective of whether the flowers are in bloom or not.

Poppies (*Papaver dubium*) taken in southern Spain, April, digitally modified using Adobe Photoshop

OUT OF AFRICA

Over the years, I have taken many conventional African animal portraits, so this time I decided to try something different. My aim was to convey a timeless African scene that could have been taken several decades ago. I copied a color transparency onto 5- x 4-inch Polacolor ER sheet film to make a print using the image-transfer process. The result was a painterly image on paper made from elephant dung bought in Botswana. Acacia trees, as depicted in the print, are browsed upon by elephants, so fibers from these kinds of trees may well be present in the paper.

Image-transfer print of Burchell's zebra (*Equus burchelli*) on elephant dung paper. Original image taken in Masai Mara National Reserve, Kenya, August

Camera: Nikon F4
Lens: 300mm
Film: Ektachrome 100 Lumière

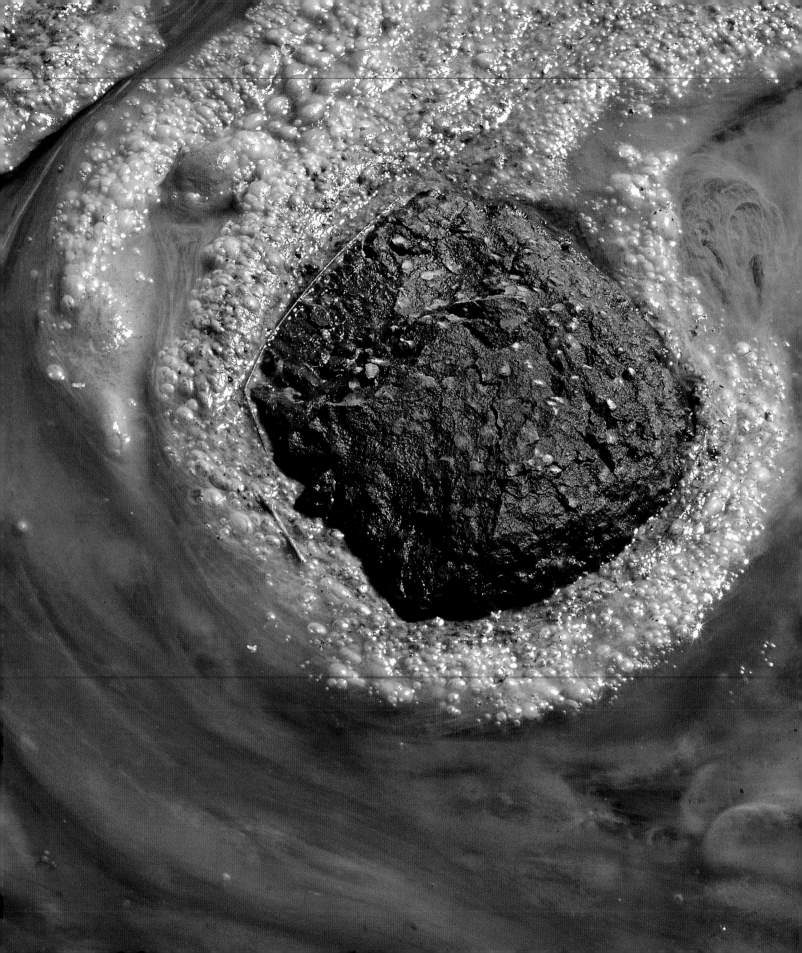

Creative Close-ups

WORKING AT CLOSE range within the natural world can bring a wonderful sense of discovery. By homing in on a tiny organism or part of a larger one, the distractions of familiar features are avoided and the eye is able to concentrate on design or surface texture. This is a case where less can be more. Bark and skin, leaves, flowers and fruits, insects and spiders, marine life, and shells are all especially rewarding subjects for working at close range. The big advantage of close-up photography is that it offers the widest potential within the smallest area. But the successs or failure of a close-up depends on making decisions about how to crop, where to focus, and what magnification, aperture, and type of lighting to use.

ALGAL ABSTRACT

Eye-catching close-ups can occur in the most unlikely places. By rotating a polarizing filter in front of my eye, I checked the enhanced color saturation of algae thriving within a warm-water stream. I used a small volcanic rock as a focal point, akin to the center of a whirlpool.

Algae in thermal stream, Iceland, July

Camera: Nikon F4S; Lens: 105mm Micro-Nikkor
Film: Ektachrome 100S; Filter: Polarizing

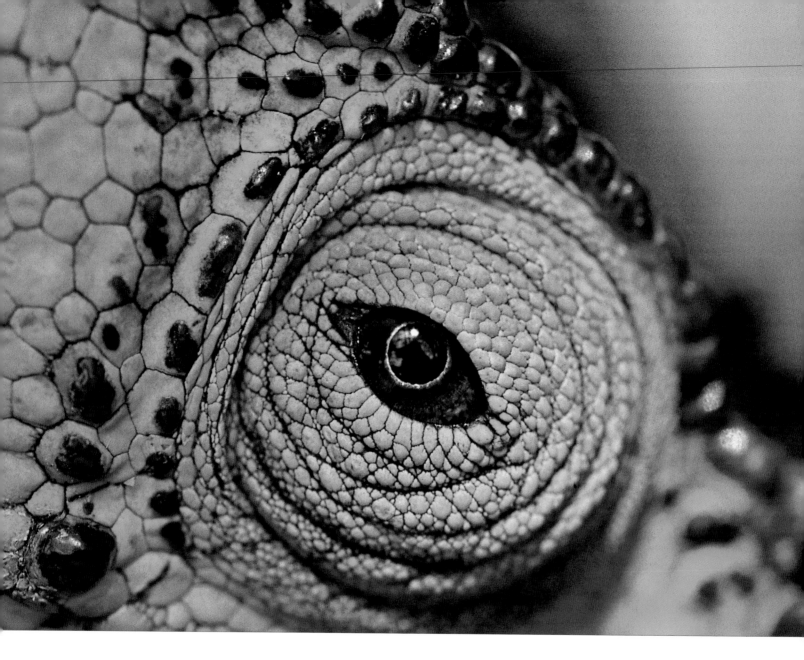

EYE ON THE WORLD

Amongst the rich array of chameleons that inhabit Madagascar, the Parson's chameleon is a large and striking example. The eye, set amid brilliant yellow scales — reminiscent of a jewel in a gold ring — makes for an arresting close-up. By using a macro lens, I gained a life-size image on the film, enlarged here seven times. Using a flash at such close range would have produced a distracting, rectangular reflection in the eyeball. Only after the film was processed did I realize that I had captured a self-portrait — albeit a somewhat distorted one — reflected in the eye!

Eye of male Parson's chameleon (*Calumma parsonii*),
Madagascar, October

Camera: Nikon F4; Lens: 105mm Micro-Nikkor; Film: Ektachrome 100S

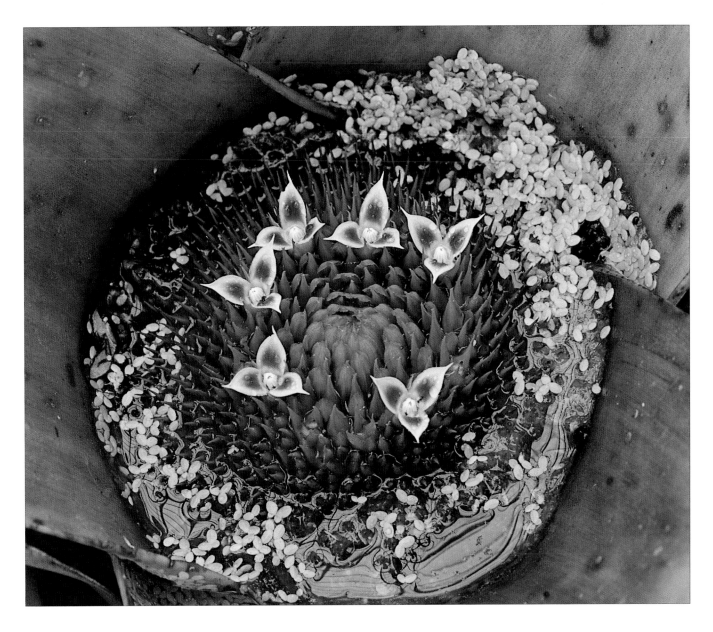

MINIATURE MOAT

Natural patterns and designs, as well as water and life in water, have always fascinated me, so it was a delight to discover this miniature moat encircling tiny bromeliad flowers. The bonus was finding the duckweed plantlets in a temporary pond, used by some South American rainforest frogs for breeding. Ensuring that the film plane was parallel to the heart of the bromeliad, I gained a close-up of intriguing shapes and colors that repeatedly lure the eye.

Duckweed (*Lemna minor*) in bromeliad (*Neoregelia concentrica*),
Royal Botanic Gardens, Kew, Surrey, England, July

Camera: Nikon F4; Lens:105mm Micro-Nikkor; Film: Ektachrome 100 Lumière

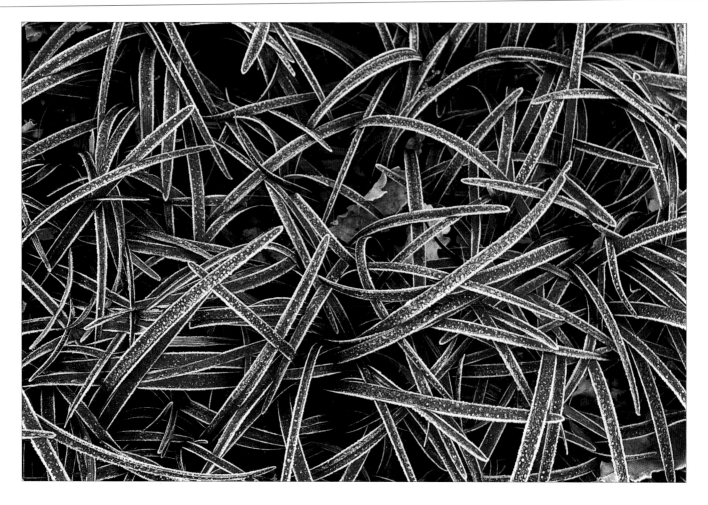

FROST ETCHING

The huge tonal contrast between these deep red — almost black — leaves and their frosty margins, together with their haphazard arrangement, produced a simple, yet graphic, image. For a brief spell, before the warmth of the sun's rays destroyed the decorative frost, this ephemeral winter close-up was quite irresistible.

Frost on *Ophiopogon planiscapus* 'Nigrescens' leaves, Surrey, England, January

Camera: Nikon F4; Lens: 105mm Micro-Nikkor
Film: Kodachrome 25

SPRING GROWTH

Virtually all year round, somber, green ivy leaves clothe tree trunks and walls in Europe. On a north-facing brick bridge, away from direct sunlight, I found some recently unfurled yellow leaves. The diagonal lines of stems bearing old and new leaves worked best as a vertical format. A week later all the leaves were green, so the picture was lost.

New growth on ivy (*Hedera helix*), Hampshire, England, April

Camera: Nikon F5; Lens: 105mm Micro-Nikkor
Film: Ektachrome 100S

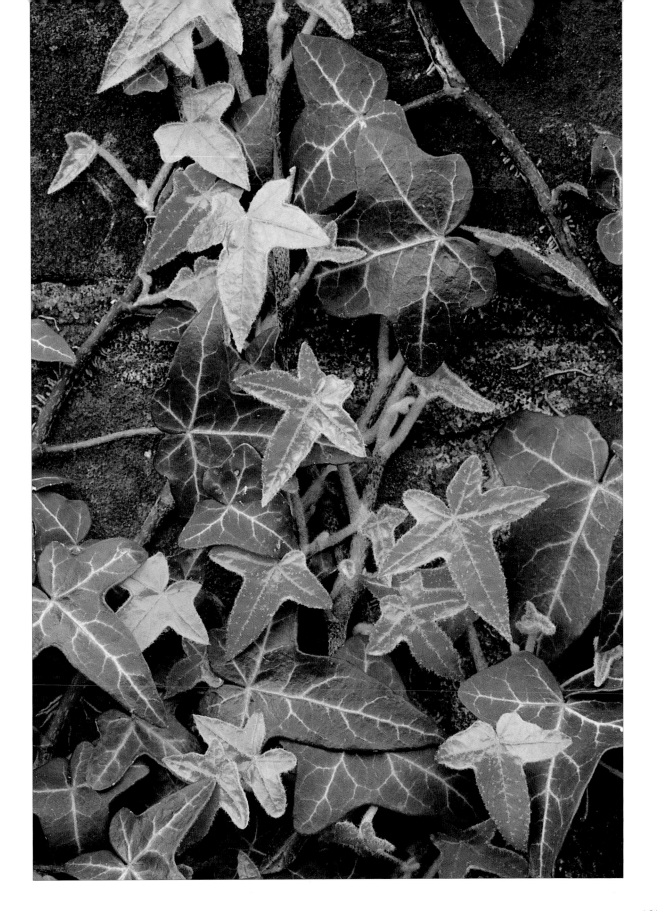

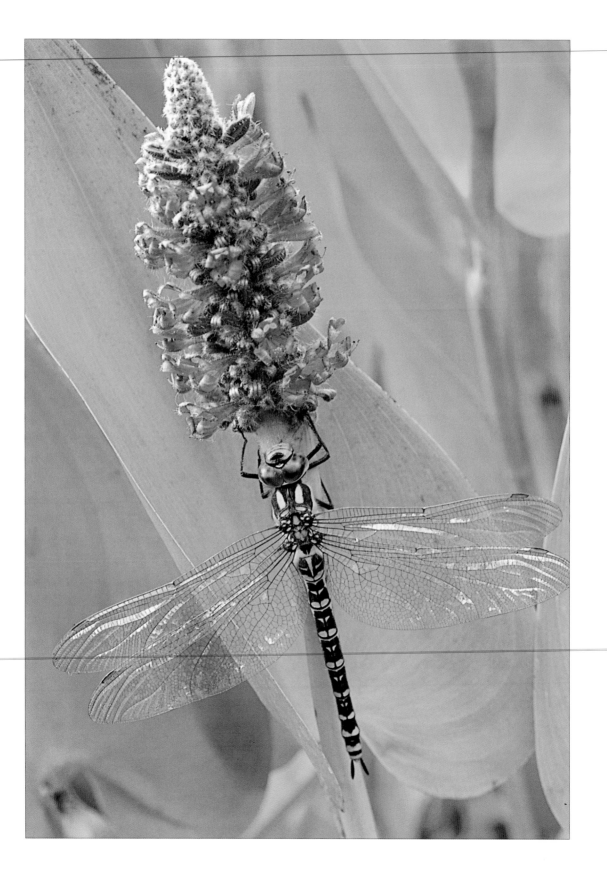

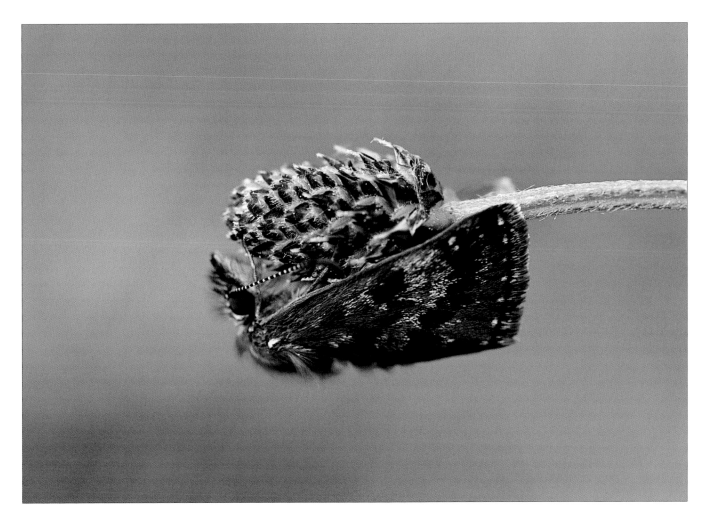

RESTING DRAGONFLY

It does not take long after a garden pond has been created for wildlife, such as amphibians and dragonflies, to invade. The easiest time to take a hawker dragonfly is after the adult emerges and clings to a plant, drying out its wings. Here, the alignment of the dragonfly's abdomen along the plant stem echoes the diagonal line of the blue flower above.

Southern aeshna dragonfly (*Aeshna cyanea*) on pickerel weed, Surrey, England, July

Camera: Nikon F4; Lens: 200mm Micro-Nikkor
Film: Ektachrome 100S

ROOSTING BUTTERFLY

One moment this butterfly was flying in the evening sunshine, the next it had alighted on a plantain head to soak up the sun's rays with outstretched wings. As clouds rolled in, the butterfly wrapped its wings around the plantain in a moth-like pose. I used a long exposure with ambient light because I didn't want flash to disturb the roosting butterfly.

Dingy skipper (*Erynnis tages*) roosting on ribwort plantain flower, Surrey, England, May

Camera: Nikon F5; Lens: 105mm Micro-Nikkor
Film: Ektachrome 100S

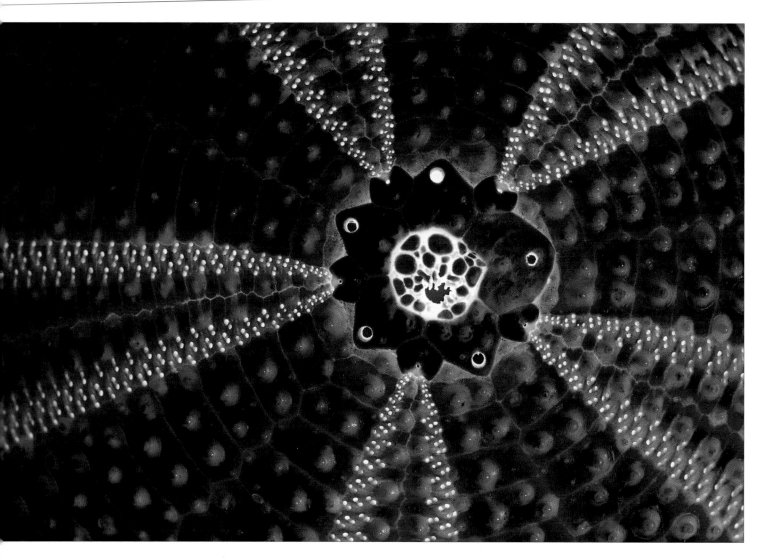

SYMMETRICAL DETAIL

Like starfish, regular sea urchins have a distinct five-ray
symmetry that shows in the outer test, or shell, after the
urchin dies. To reveal the radiating lines of holes where
the suckered feet emerged through the test, I beamed fiber
optics inside it. Also visible are the protuberances that
form the bases of the spines' ball-and-socket joints.

Test (or shell) of sea urchin (*Echinus esculentus*),
Pembrokeshire, Wales, March

Camera: Nikon F4; Lens: 105mm Micro-Nikkor
Film: Ektachrome 100S

SUCTION POWER

The tiny, suckered tube feet on the underside of starfish
arms have such an effective grip that they can pull apart
the shells of a live bivalve oyster or scallop. They even
allow a starfish to walk upside down on the ceiling of a
cave. I used natural lighting to take this wet starfish
exposed at low tide with three tube feet gripping a rock.

Starfish (*Pisaster ochraceus*),
British Columbia, Canada, August

Camera: Nikon F4; Lens: 105mm Micro-Nikkor
Film: Kodachrome 25

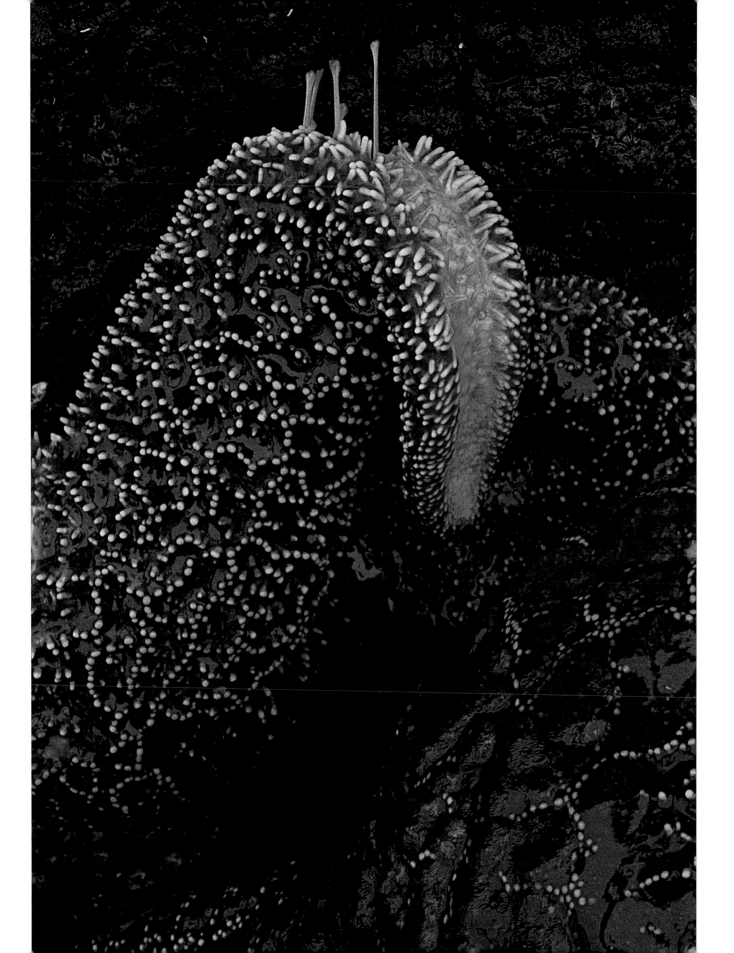

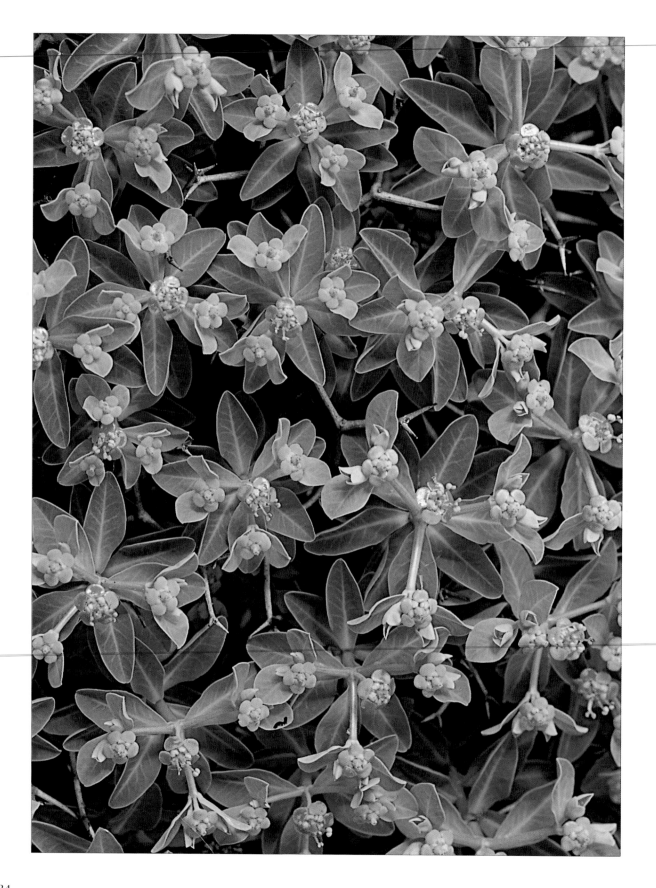

REPETITIVE DESIGN

Shrubs that produce their shoots in a regular pattern invariably make for graphic close-ups. The flowers on this euphorbia are insignificant, but they make a design with the leaves. By cropping in tight and filling the frame, I did not have to worry about conflicting shapes or colors appearing behind the plant.

Euphorbia acanthothamnos, Royal Botanic Gardens, Kew, Surrey, England, May

Camera: Nikon F4; Lens: 105mm Micro-Nikkor
Film: Ektachrome 100S

SUMMER AWAKENING

High in the Colorado mountains, snow lingers within shady hollows until midsummer. On one patch, remnants of male cones and needles of conifers formed a random pattern. Glacier lily leaves breaking the surface represent the awakening of new life, punctuating the remains of winter — the candles on the icing, as it were.

Glacier lilies (*Erythronium grandiflorum*) breaking through snow, near Crested Butte, Colorado, USA, July

Camera: Nikon F4; Lens: 105mm Micro-Nikkor
Film: Ektachrome 100S

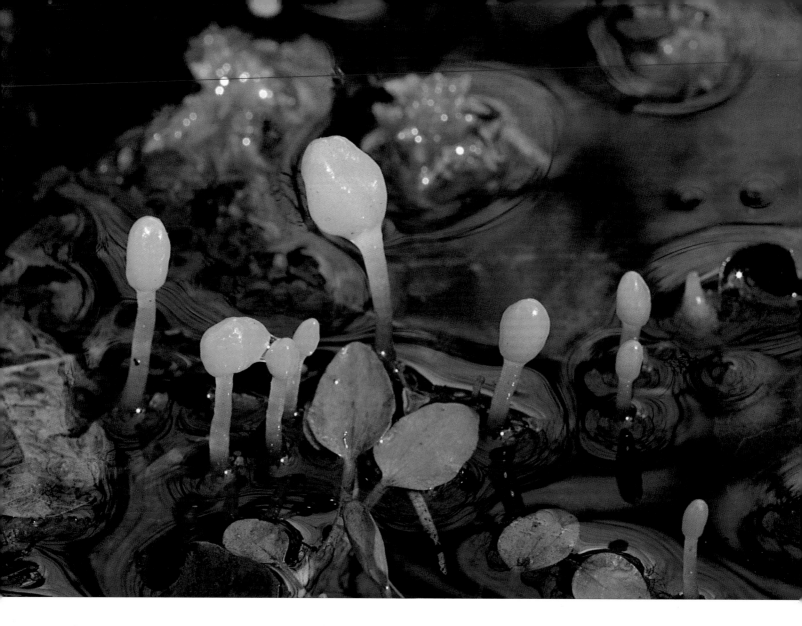

SWAMP CANDLES

Moving through a swamp is always an effort as mud sucks at your feet. My quest was for a small fungus that develops in spring on rotting leaves, and appears to glow with a luminosity of its own. Using a low camera angle, I captured the abstract reflections within a surface film, fragmented by plants erupting through the meniscus.

Bog beacons (*Mitrula paludosa*) in swamp,
New Forest, Hampshire, England, April

Camera: Nikon F4; Lens: 105mm Micro-Nikkor
Film: Ektachrome 100S

FLAKING BARK

From a distance it was the luminous, yellow lichen that caught my eye, but when I began to focus the lens I was intrigued by the flaking bark. Each portion resembled a piece of a jigsaw puzzle, and later I discovered that this is a feature of the ponderosa pine. The colors of both the bark and lichens were enriched by rain.

Bark of ponderosa pine (*Pinus ponderosa*),
British Columbia, Canada, October

Camera: Nikon F5; Lens: 105mm Micro-Nikkor
Film: Ektachrome 100S

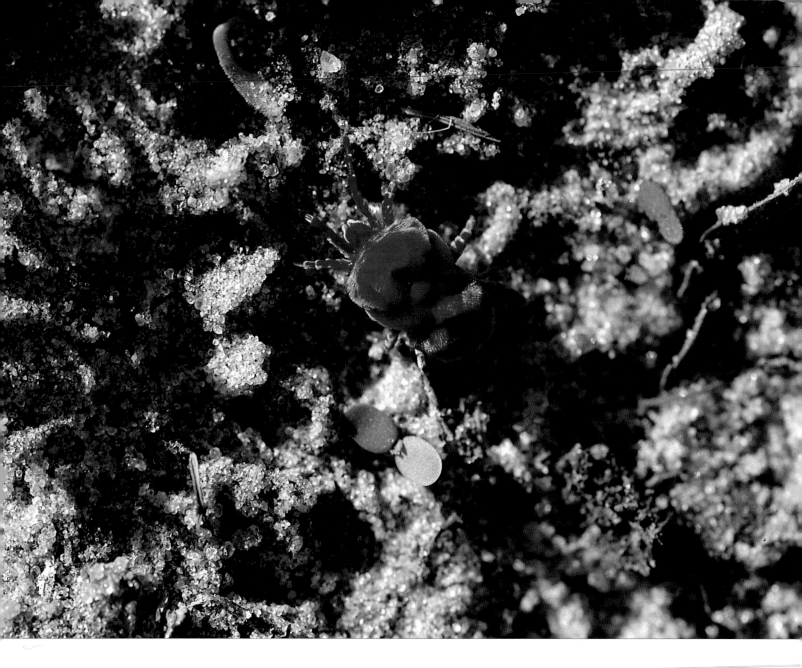

VELVET MITE

Velvet mites appear in Africa after it rains, but they are so small that it is quite impossible to spot them from a jeep. When seen at close range, they resemble mobile, miniature pincushions. By mounting the camera on a tripod, with the film plane parallel to the ground, I could maximize the small depth of field for a life-size image on film.

Velvet mite (*Dinothrombium* sp.), Moremi Game Reserve, Okavango Delta, Botswana, November

Camera: Nikon F4; Lens: 105mm Micro-Nikkor; Film: Ektachrome 100S

HYENA IMPRESSION

Identifying recent animal tracks in dirt roads or the muddy margins of waterholes is a useful way to determine predator movement. At the edge of a pool with a colorful, microscopic algal bloom, I noticed that a hyena foot had peeled away the damp algal layer from the mud. Here, the color contrast accentuates the shape of the footprint.

Spotted hyena (*Crocuta crocuta*) footprint in algal-covered mud,
Moremi Game Reserve, Okavango Delta, Botswana, February

Camera: Nikon F5; Lens: 105mm Micro-Nikkor; Film: Ektachrome 100S

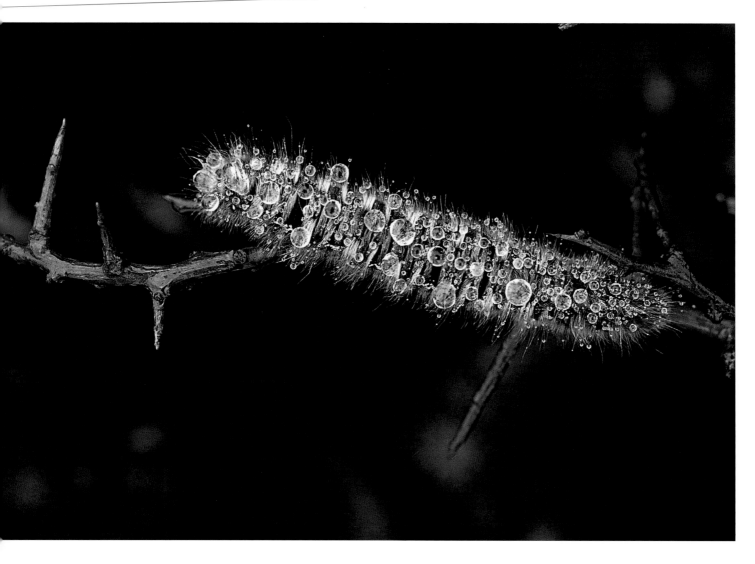

DECORATIVE RAINDROPS

It was only after light rain began to fall that I noticed a hairy caterpillar bespangled
with gem-like raindrops. The simplicity of this close-up is enhanced by the
caterpillar having eaten the leaves and completely defoliated the branch! I metered
the light by manually spot-metering a green leaf out of shot.

An eggar caterpillar (*Lasiocampa* sp.), The Burren, County Clare, Ireland, May

Camera: Nikon F5; Lens: 105mm Micro-Nikkor
Film: Ektachrome 100S

WATERDROP LENSES

When raindrops are photographed larger then life-size, they function as miniature fish-eye lenses. Within each drop on this aquatic plant is an inverted image of the pink water lily flower, visible as an out-of-focus backdrop. Not all of the drops are lying in a single plane so, given the shallow depth of field of the lens, some inevitably appear less sharp than others.

Waterdrops as fish-eye lenses, Surrey, England, July

Camera: Nikon F4; Lens: 105mm Micro-Nikkor + X1 close-up lens; Film: Ektachrome 100S

Index

Acknowledgements

It would not be possible to produce a book that covers such a rich assortment of wilderness areas spanning the globe without a great deal of help from so many people.

Travel agents, guides, botanists, zoologists, friends, and photographers all helped me achieve my goals. In particular, I should like to thank: 4 X 4 Mountaineers (Iceland); Agfa Gevaert Ltd.; Dr Akira Aoki; Animals of Montana Inc.; Arctic Experience Ltd.; Benbo tripods; Reneé Bish; Marek Borkowski of Wildlife Poland; China Span; Gordon Dickson; Eco-Expeditions; Joe Englander; David Gray; Judi Kask; Peter Harrison; Hasselblad (UK) Ltd. for the loan of equipment; Huntington Botanic Garden; International Wildlife Adventures; Joseph Van Os Photo Safaris; Knight Inlet Lodge; Kodak Ltd.; Trevor Lindegge; Los Molinos Centro de Fotografia; Renee Lynn; National Trust; Naturetrek; Nikon (UK) Ltd.; David Oswin Expeditions; Pete Oxford; Amy Pavelich; Polaroid (UK) Ltd.; Royal Botanic Gardens, Kew; Peter Sharp; Gatat Sudarto; Twycross Zoo; Wildfowl and Wetlands Trust for access for photography; Ken Willmott, and Zegrahm Expeditions.

Special thanks go to Wildlife Worldwide Ltd. for arranging several trips to Botswana via Okavango Wilderness Safaris based in Maun; to the staff and guides at Mombo and Xigera Camps; to Advance Colour Techniques for making my duplicates; to Colour Processing Laboratories in Reading, England, for their speedy and reliable processing; to Valerie West, who converted my copy written on airplanes into the final manuscript; to my son, Giles Angel, for assisting me on a winter Iceland shoot, editing many films and, not least, for introducing me to the exciting world of digital imaging; and to my husband, Martin Angel, for his constant support and encouragement.

My grateful thanks go to Sarah Hoggett, who so enthusiastically initiated the concept of this book, as well as to the rest of the Collins & Brown team – notably Claire Graham, the designer, and Ian Kearey, my editor.